# THE PAINTER'S
# WORKSHOP

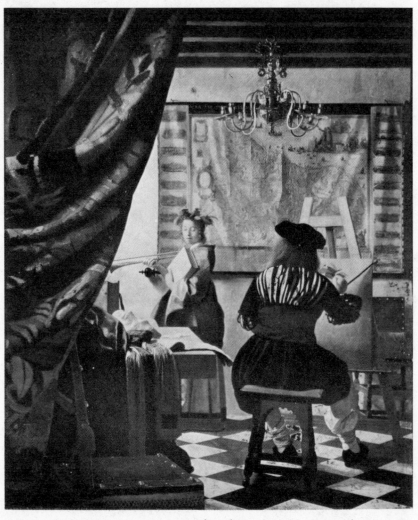

AN ARTIST IN HIS STUDIO, by Johannes Vermeer (1632–75)
*Vienna Gallery*

# THE PAINTER'S WORKSHOP

---

W. G. CONSTABLE

DOVER PUBLICATIONS, INC.
NEW YORK

First published in 1954 by Oxford University Press.

Published in Canada by General Publishing Company, Ltd.,
30 Lesmill Road, Don Mills, Toronto, Ontario.
Published in the United Kingdom by Constable and Company,
Ltd., 10 Orange Street, London WC2H 7EG.

This Dover edition, first published in 1979, is an unabridged
and unaltered republication of the work originally published
in 1954 by Geoffrey Cumberlege, Oxford University Press,
London. The present edition is published by special arrangement
with Oxford University Press.

*International Standard Book Number: 0-486-23836-9*
*Library of Congress Catalog Card Number: 79-50613*

Manufactured in the United States of America
Dover Publications, Inc.
180 Varick Street
New York, N.Y. 10014

IN HOMAGE TO
WILSON STEER
AND
HENRY TONKS

# PREFACE

CRAFTSMEN and scientists may feel that this book, intended for laymen and certain of those who profess and call themselves art historians, profanes their skill and learning. If so, I ask for their indulgence. Especially do I seek this from Richard D. Buck, John Finlayson, Alfred Lowe, Arthur Pope, Ian Rawlins, George L. Stout, and William J. Young, whose brains I have consistently picked, and without whose counsel and help this book could not have been written. Also, I am deeply indebted to my wife for critical reading of the text and much help in proof-reading.

<div align="right">W.G.C.</div>

1953

# CONTENTS

# LIST OF PLATES

# THE PAINTER'S
# WORKSHOP

# I

## INTRODUCTORY

THE following pages are in no way intended to be a history of the materials and methods used by painters in the past. Even less do they aim at being a manual of instruction for painters. Both history and practice have been subjects of a formidable array of books, some based upon patient research, others upon the writers' intuitions, many of them highly speculative and controversial. But cleared of speculation and controversy, there remains a solid body of knowledge as to the various ways in which paintings have come or may come physically into being; and this book is designed to put before the layman who is interested in painting, the main elements of such knowledge. It should be understood, however, that what is said relates only to Western painting. The painters of the East had their own materials, their own way of using them, their own system of training, and their own place in society, all calling for specialized knowledge and treatment.

Too often it is forgotten that painting is a craft as well as an art, and, moreover, a difficult craft. At first sight, to dip a brush into a pot of paint and apply it to a surface, seems easy enough. But anyone who has tried to paint his own house knows differently. Trouble immediately arises about the way the material to be painted receives the paint, the consistency of the paint, the suitability of the brush, getting an even surface on the paint, and how to prevent paint going where it is not wanted, especially on to the painter himself. Even if these difficulties are overcome, there remains the question whether his work is going to last. Imagine, therefore, how much more complicated is the painting of a picture, which is to be the expression in

visual terms of an artist's ideas and emotions. It is not too much to say that on the mastery of his craft depends the artist's power to say fully and completely what he has to say. This is not to imply that a great craftsman is necessarily a great artist. On the contrary, many painters with much technical knowledge and great dexterity of hand are sadly deficient in thought and feeling; witness many of the exhibitions at the French Salon in the past hundred years. In contrast, painters with very limited technical resources can produce work that is deeply moving; though almost invariably it will be found that what they produce is an adumbration, or at best a partial expression, of what they feel, and that it would be more impressive had means been more responsive to ends.

In considering painting as a craft, however, there is an important distinction to be made; that between dexterity in handling tools and materials, and knowledge of the characteristics of those materials and of how they can best be combined into the structure of a painting. In the nineteenth century, especially, these two were often divorced, and painters who could use paint with extraordinary speed and certainty to attain their aims, yet used materials which were liable to change in colour or in structure, or combined materials in such a way that rapid disintegration was inevitable. Reynolds and the succeeding generation of English painters used asphaltum or bitumen, a rich brown pigment which quickly darkens and cracks irremediably; some nineteenth-century painters used the recently discovered aniline colours, which fled within a few years; other painters of the nineteenth century mixed their pigments with 'megilp', a combination of oil and mastic varnish which led to splintering and cracking; Whistler would paint thinly on a dark ground, unaware that the paint would lose body and become more transparent, and the painting darken to the tone of the ground; and Sargent would go on with his work when the underlying paint was half dry and sticky, using a coat of so-called retouching varnish to make this possible, and thereby creating a series of layers which contracted at different rates while hardening, and so inevitably caused cracking. Into dangers of this kind the un-

skilled painter is particularly liable to fall, since in seeking for some particular effect or quality in his work he may not realize that he is using dangerous methods or unstable materials.

It must not be thought, however, that there is one standard set of materials and processes, which the painter deserts at his peril. On the contrary, there are various types of painting, notably fresco, water-colour, and oil, which involve very different materials and processes. Also, in each of these types, materials and procedure can vary considerably, though for each type the range of suitable material is restricted, and its handling must conform to certain basic principles. It is when the painter goes outside limits thus set that he runs the risk of losing technical control, or of disaster.

The artistic importance of these possible variations in the process used and the way it is used is not always fully realized. Each process has its own particular possibilities and limitations, so that some things can be done in terms of one that are difficult or impossible in another. Consequently, according to the painter's conception, to his temperament, and to his knowledge of and skill in handling a process, he will choose one rather than another, exploiting its special qualities, and accepting its defects. Likewise, if circumstances such as the purpose of the painting or the wishes of a patron make the use of a particular process obligatory, the artist may have to adjust his ideas, and certainly the way he expresses them, to what that process allows. So it comes about that the conception and emotional content of a painting are bound up with its technical character. As Walter Sickert, a painter of distinction and a penetrating critic, well says (in *A Free House*, p. 226): 'Every material has its own art. In its kind, a work executed in it is better or worse according as it brings out to greater or less advantage the special qualities that the particular instrument is fitted to bring out, and that another instrument cannot bring out as well.'

This importance of material is recognized by the growing practice in catalogues and books about paintings, of giving the material in which they are constructed, of describing the way that material has been handled, and even of describing the present condition of

paintings. Partly, such details are a useful means of distinguishing one work from others similar in subject and design. But they also emphasize that consideration of a painting as a work of art cannot be divorced from an understanding of its physical character. The attempt in some circles to disregard this, and to regard every painting as made out of some universally pervasive substance, has provoked remarks such as 'What a pity so-and-so did not do such-and-such', without realization that the materials he used effectively prevented anything of the kind. It is rather like lamenting that Shakespeare did not write in Greek.

So it is that some knowledge of materials and technique will help to make more understandable much that is written about painting. But it can do more than this. It can yield the pleasure inspired by the sight of good workmanship, and of seeing an end attained with precision and elegance. Again, especially in the case of old pictures, time is apt to bring changes. Pigments change colour; varnishes darken or disintegrate; and the hand of man may have added repaints, so that the artist's intentions are obscured. Some knowledge of what may have taken place permits mental and emotional adjustments to be made, so that the spectator can get nearer to the artist and not be misled by something that was never intended by him. Again, knowledge of materials and processes is part of the equipment for understanding why a painting is what it is and not otherwise; and what were the technical limitations and possibilities which controlled the artist. More important still it helps to prevent a work of art being regarded as an archaeological specimen, which exemplifies some particular phase of thought, or some particular culture. Entering into the physical process by which the painting has been created, realizing how difficulties have been solved or not solved, does much to bring the spectator into the living presence of the artist.

One word of warning is necessary. A knowledge of materials and processes is only one part, and a comparatively small part of what an artist must bring to the making of a painting, and a spectator to its study. It has been well said that 'what makes a medium artistically important is not any quality of the medium itself but the qualities

of mind and hand its users bring to it'. But a knowledge of what materials an artist has used, and how he has used them remains indispensable for full understanding of what is present in a painting and why it is there, and is therefore a basic element in trying to realize what the painting is as a work of art.

# 2

## WORKSHOP ORGANIZATION
## AND EQUIPMENT

THE temperament and approach to his work of the painter today seems to be very much the same as that of the painter in the past. Patience, skill, and devotion were not a monopoly of the older masters, nor are haste and inferior workmanship the necessary characteristics of the moderns. We today are apt to judge the work of the past by its cream, which has survived on museum and gallery walls; but anyone who has had experience of old collections, or frequents auction sales will realize how much inferior work was produced in the past, quite apart from the immense amount that has deservedly perished. Similarly, early painters are sometimes credited with a knowledge and learning they never possessed. For example, art historians have been known to search the classics for explanation of a subject, implying that the painter had not only a knowledge of Greek and Latin, but time to make use of it; while the true source was a textbook of the painter's own day, the then equivalent of, say, Bulfinch's *Age of Fable*.

But the circumstances in which the painter worked have undergone great changes. Primarily, these have come about owing to changes in the place of the artist in society, which is bound up with changes in the painter's own conception of his business, and with changes in the system of patronage.

Broadly speaking, during the Middle Ages and until well on into the fifteenth century the painter was regarded and regarded himself primarily as a craftsman working with a particular set of materials. In the earlier Middle Ages, artistic activity mainly centred in the

monasteries, since the greater part of the demand for works of art came from the Church, either directly or through lay benefactors. We know little about the organization of the monastic workshop; but it is certain that the idea, which was widespread in the nineteenth century, that the workmen themselves were mainly monks, is erroneous. No doubt some of the work was done by monks; but it is certain that laymen were extensively employed.[1] In the later Middle Ages, artistic employment was almost entirely in lay hands; and the painter, with other craftsmen, was obliged to be a member of a guild unless he were in the employment of a ruling prince, in which case he was exempted; but even so, however generously he might be paid he ranked as a tradesman, and any title he received (such as that of *valet de chambre* given to Jan van Eyck) might also be conferred on clock-makers, butchers, and so on. The painter's position as a craftsman is emphasized by the fact that in many places the painters did not have a separate guild, but were associated with other trades. In Florence, for example, from the early fourteenth century they were members of the guild of doctors and apothecaries (*Medici e Speciali*). In this they were not regarded as fully privileged members, and shared membership not only with other kinds of craftsmen, but with dealers who supplied the materials of the crafts represented. Likewise, in Brussels, the painters were in the same guild as the goldsmiths and printers; and in Bruges, painters were at one time associated with saddlers, glass-makers, and others. Later, however, the painters almost invariably, especially in large centres, came to have their own guild.

The guilds were primarily economic organizations; but they usually developed religious and social activities, though sometimes (as in Florence) the painters adhered to a distinct and separate organization, generally dedicated to St. Luke, which was concerned with this side of guild activity. St. Luke was regarded as the patron saint of painters, he himself being reputed to have been a painter, and to have painted a portrait of the Virgin. This religious and social aspect of medieval painters' organizations is the probable source of the legends concerning the piety and devotion of the medieval artist. In

[1] See G. G. Coulton, *Art and the Reformation*, 1928, for an account of the controversy.

fact, he seems to have been much the same kind of human being as the nineteenth-century workman, with his savings bank, his sick club, and his church. But from the economic and craft point of view, the guild was of the highest importance. It was composed of masters or heads of workshops. Rules of admission varied from place to place, but normally candidates for admission had to give evidence of having completed their apprenticeship and submit proof of their competence as craftsmen. Members acted in turn as officers of the guild, and as such were concerned not only with discipline within the guild, but with its relation to other guilds and to the civic authorities. As mentioned above, a painter could not practise his craft unless he were a member of the guild, though a guild member would usually receive the freedom of the local guild whenever he travelled.

Guild regulations mainly concerned four aspects of the painter's work; the kind of work he could accept, the materials he used, the organization of his workshop, and relations with his patrons. These rules varied from place to place, and from period to period, but had a generic likeness. As regards the work a painter was allowed to do, certain kinds of painting might be allotted to certain guilds. Thus illuminators might be in a separate guild, as at Bruges; and with the tendency of the painters to develop their own organizations independently of other craftsmen, such restrictions on the membership of guilds were inclined to multiply. On the other hand, within his allotted sphere, the painter had to meet all the requirements of his patron. He could not limit himself to any particular process, and was expected to supply paintings on walls, as well as on panel or canvas for which he might also make the frames. He might be called upon to paint religious, civic, and military banners, heraldic shields, and to provide decorations for public pageants; he was sometimes asked to supply designs for embroidery and metal-work; and the painting of architectural details and of sculpture was a regular part of his activity. Moreover, in places where the demarcation of function had not become rigid, the painter might also be sculptor and architect. Thus, the present-day idea of the painter as a highly specialized artist, who may even restrict himself to one particular type of painting,

such as portraiture, and who usually works in one type of material, was quite foreign to the Middle Ages. His position, indeed, was much more akin to that of a high-class cabinet-maker and joiner in the nineteenth century.

The materials used were also regulated and controlled by the guild. In contracts the use of certain pigments might be stipulated, and the substitution of others might lead to a fine. In fourteenth-century Florence, for instance, the use of 'German blue' instead of ultramarine, was prohibited. Usually, the regulations regarding materials of the guilds in northern Europe were stricter than in Italy, and in Flanders, for instance, the preparation of wooden panels was carefully regulated. Here, again, there is nothing strange or esoteric. Medieval practice in the arts is strictly comparable to modern legislation which requires the maker to describe on the outside of the packet the composition of certain proprietary articles, drugs, and foodstuffs.

The workshop, also, had to be organized within a prescribed framework. According to his wealth and the amount of work to be done, the master employed paid assistants or journeymen, so called from their being originally paid by the day. From these men, the ranks of the masters were normally recruited, but some of them remained journeymen all their lives. They were free to travel, and could move from workshop to workshop. In addition, each master usually took apprentices. These received no pay, but lived with the master, who fed, clothed, housed, and instructed them. They had to learn their craft from the bottom up, and in addition to the menial work of the studio, learned how to prepare pigments and mediums, and to grind them together; to prepare panels and other materials to be painted upon; and to do some of the early and more elementary stages of a painting. The apprentice was bound to the master for a specific number of years, and the master had definite responsibilities towards him, laid down by the guild. The number of apprentices one man could take was also limited, to prevent exploitation and what was regarded as unfair competition.

From this brief account it will be evident that the work which issued from a medieval painter's workshop was much more the result

of a joint activity of the whole shop than of any particular individual. How pervasive was the idea of joint production is emphasized by the fact that for large and important pieces of work the contract might specify that certain masters should collaborate; in the case of, say, an altar-piece, one being responsible for the central panel, and another for the wings, and a third for the frame. Such collaboration, either within a workshop or between workshops, must not be thought of as something characteristic of a better and brighter world, now vanished. It may have practically disappeared among painters today; but it still flourishes in the modern architect's studio. It means, however, that in the Middle Ages a master might sign and be paid for a painting; but that this is no indication of how far it was the work of his own hands, a fact emphasized by contracts sometimes laying down that the principal part of the work should be done by the master himself.

The medieval conception of the painter, and the organization of his workshop also helps to account for the anonymity of a great deal of medieval work. As a craftsman working in an organized group, a painter's identity was largely merged with that of others, and to mark any particular product of a shop as the work of any particular man was unusual; and it is only in the later Middle Ages that signed work becomes at all frequent.

Another point to be noted is that the workshop organization of the Middle Ages involved a strong unwritten tradition of craftsmanship. Numerous books of recipes for making materials and instructions on how to use them survive from the period, but the difficulty of interpreting them and of applying them makes it clear that they are mainly memoranda which can be fully understood and properly used only by those with a background of lore and knowledge handed down from generation to generation, through the hierarchy of master, journeyman, and apprentice. Another difficulty in understanding and using early recipes is that we sometimes do not know exactly what is the material described by a given name. Even if we know this, we do not know the degree of its purity, and it may be that it was the presence of some alien substance that gave the material its special value in use.

Lastly, the guild had some control over a painter's relations with his patrons, through the contracts which were customary. These had to be within guild rules; and the guild would be active in securing their observance. Today, commissioned work with some kind of contract is exceptional save in the case of portrait-painting. In the Middle Ages it was the rule. Though a certain amount of small routine work seems to have been done for chance customers or for export, the bulk of a painter's work was for definite persons and definite purposes. Important or costly work would never be undertaken at a venture, and was the subject of a contract which specified not only materials, time of delivery, amount and terms of payment, but also the subject and its treatment. The great proportion of painters' work was for religious purposes; and not only would the subject be determined by the place the picture was to occupy, and the purpose it was to serve, but certain rules and conventions had to be observed in its treatment, partly laid down by the Church, partly the result of tradition. This is not the place for a dissertation on the subject-matter of medieval painting, but it is important to realize that the medieval painter had to exercise his imagination and ingenuity within a predetermined framework.[1] Sometimes this would be imposed upon him from the outside to meet special needs and circumstances, but normally it was part of the everyday equipment of the workshop, transmitted from one generation to another.

In the course of the fifteenth century, with the breaking up of medieval social organization, not only did the place of the guild in society change, but its relation to the painter. The social status of the artist had been rising; and from acceptance of his position as an artisan and craftsman, he passed to claiming that the visual arts should be regarded as among the liberal arts, and that those who practised them should rank with scholars and literary men. This point of view found powerful exponents in Leonardo da Vinci and Michelangelo. Leonardo in particular argued that painting, sculpture, and architecture are distinct and different from the mechanical arts, since they involve knowledge of science, and especially of mathematics, while

[1] On this, see also Chapter 8 below.

the mechanical arts are based on manual labour, upon which Renaissance society, equally with that of the Middle Ages, looked down. Meanwhile, the artists themselves were in active controversy as to which art ranked above the others, though this did not affect the fact that by the sixteenth century painting was more or less accepted throughout western Europe as one of the liberal arts. This position it has held ever since, despite disputes as to the order in importance of historical, landscape, portrait, and other types of painting; and is the source of the distinction between the Fine Arts and the Applied Arts or Crafts, which is current today.

The change in the status of painting was one of many which led both to the decay of the guild and to alteration in the painters' economic position. The guilds continued to exist, some of them until late in the eighteenth century. In northern Europe they here and there continued to exercise some control over painters. For example, seventeenth-century Flemish paintings are sometimes on panels which are marked with the guild stamp of approved quality. But, in general, the sixteenth-century painter disregarded them, and attempts by the guilds to exert their authority came to nothing. No longer were the main sources of patronage confined to the Church and to the Court. Great noblemen and the wealthy bourgeoisie entered the market for the painter's wares, while the demand changed from being almost exclusively religious or official with a specific purpose or place in view, to being in part secular, to please the taste of an individual. The day of the collector as an important source of the painter's income had arrived.

Paintings with their subject-matter and treatment dictated or controlled by the patron were still probably in the majority. This was especially the case with series designed to decorate rooms in some great man's house or in some public building. Not only would there be a controlling idea within which each painting played an allotted part, but the details of each one would be worked out with great elaboration. Such series were characteristic of the High Renaissance, subject and interpretation not being left to the painter but provided for him, perhaps by the patron, perhaps by some scholar employed by him. This practice of supplying programmes to artists, with de-

tails as to their carrying out, continued through the seventeenth and eighteenth centuries; but increasingly the painter used subjects and descriptions which he found and chose for himself in books, a practice that went on well into the nineteenth century.[1]

Religious painting during and after the Renaissance similarly might have subject and interpretation controlled by authority external to the painter. There was, however, a continuous tendency for painters to break away, as when Paolo Veronese was brought before the Inquisition for introducing into his *Feast in the House of Levi* (now in the Academy, Venice) buffoons, German soldiers, and other details which the Church regarded as improper, but which Veronese argued were part of the decorative ensemble. But for a period following the religious revival connected with the Council of Trent, control was tightened in the countries in which the Church was still powerful. Not only were subjects or series of subjects chosen and treated to give expression to Church teaching; but nudity in religious painting was strictly regulated, and older paintings judged improper would have draperies added to them.

In fact, the practice of painting for specific places and specific purposes continued until much later than is often supposed, and persisted throughout the nineteenth century. But at the same time, the painter played an increasingly large share in selection of subject, and became increasingly the final authority as to how it should be treated. Particularly was this the case with easel paintings, whose subjects were chosen without reference to any particular patron or purpose, the painter taking his chance of finding a buyer. Seventeenth-century Holland is a case in point. In this Protestant, middle-class, commercial community the demand for public religious art, or for large secular decorative projects, was practically non-existent, and the bulk of commissioned work was portraiture. Religious subjects, landscape, genre, and still life were painted not for particular positions, but to

[1] A curious survival of this literary connexion, though little more than a gesture, was the common practice during the nineteenth century of landscape painters attaching to their works suitable literary quotations, which Turner even went to the length of coining himself.

be framed and hung upon the walls of moderate-sized houses, and the great majority were painted at a venture. So there developed as in no other country the trade of the art dealer to whom the painter could takes his wares and to whom the patron could go to seek what suited his taste and fancy. Indeed, the days of the exhibition as a means of advertising what the artist had to sell were not far away.

Tied in with these changes in social status and economic position of the artist was development of a new type of artists' organization, the Academy. Early examples were formed in Italy in the sixteenth century, and in various forms such bodies have persisted until the present. The conception which underlies them all is that of a professional association of learned men, which exists to promote the study of the arts in their theoretical and scientific aspects, as well as on the practical side. Many of them organized schools of drawing both from casts and from the life, which was regarded as the basis of all sound instruction in perspective and anatomy. In some cases, too, the organization of exhibitions became an important part of Academy business. But though originally an outward and visible sign of a new freedom for the painter, through his emancipation from the guild and from the dictates of a patron, and through his reception into the ranks of the learned professions, in some cases the academies became the means to a new tyranny. Especially was this the case in France. There, the Academy of Painting became part of the machinery of absolute and centralized government built up under Louis XIV, which persisted through most of the eighteenth century; and by virtually limiting state and court patronage to Academicians, and by strict regulation of qualifications for admission, helped to enforce a set of standards as to conception and treatment fully as rigid as anything contrived in the Middle Ages.

Despite the schools of drawing and other formal instruction conducted by the academies, the technical training of a painter proceeded on similar lines to those followed in the Middle Ages. The old system of a regulated apprenticeship and of journeymen with a definite status disappeared; but the would-be painter had to learn his craft in the studio of a painter. Incidentally, it is characteristic of the

artist's change in status that in Italy the old term *bottega* (shop) should have been replaced by the term *studio*, current today. At a comparatively early age a boy would go as a pupil, and take his part in the everyday work of the studio, including the preparation of materials. Later he might become assistant to the master, until ready to become independent. Also, the use of assistants on a large scale was common, their individuality being merged in that of the master while working with him. According to the wealth and professional standing of the master, the quality and number of these assistants varied. Rubens could employ Van Dyck, Jordaens, and Snyders; Richard Wilson had to be content with the help of pupils.

So it came about that a great part of the knowledge and practice of the sixteenth-, seventeenth-, and eighteenth-century painter was almost as much the result of workshop tradition as that of his medieval predecessor. In books on painting, accounts of procedures may be more rationalized, but still imply a background of unwritten knowledge. Likewise, it followed that much of the painting of those centuries was, equally with that of the Middle Ages, the result of joint production; and that in the absence of outside evidence such as contracts or other documents, there is no complete certainty that a work which came from a particular painter's workshop, and for which he was paid, is entirely by his hand. A painting may carry the signature of Giovanni Bellini; but only a certain level of workmanship and uniformity of quality enable us to assume that it is by his hand, and, even so, opinion may differ from generation to generation. So a *Schlangel* (dragon) may appear on a panel from the Cranach studio, but is no guarantee of its being wholly by Cranach himself. Such signatures or devices in fact were rather in the nature of trademarks than of signatures in the modern sense of the term. That the same situation existed in the studio of Dürer appears from his correspondence with Jacob Heller of Frankfurt, over a triptych painted for him. The centre-piece (an Assumption of the Virgin which was destroyed in a fire in the seventeenth century) Dürer undertook to paint with his own hand, saying 'No one shall paint a stroke but myself', but

references to the wings make it clear that they are largely by assistants, a typical remark being 'The inner ones are quite grounded, so that they may begin to paint on them'.

The work of Rubens provides perhaps one of the most difficult problems. Employing as he did such brilliant assistants as Van Dyck, Jordaens, and Snyders, quality alone is no sure ground for judging how much of a particular painting is by Rubens. We may often be sure he provided the design, on the basis of a sketch which can only be by him; we can sometimes reasonably assume that he put on the finishing and decisive touches, but how much of the intervening work was his? So opinion swings to and fro not only over individual pictures, but over such series as the famous one representing the history of Decius Mus in the Leichtenstein collection. Rubens's practice is clearly revealed in a long correspondence he had in 1618 with Sir Dudley Carleton, concerning the exchange of some of his own pictures for a collection of antiques owned by Carleton. In the list of the pictures he offers such phrases occur as 'Original, by my hand, and the Eagle done by Snyders'; 'Original, the whole by my hand'; 'Commenced by one of my pupils, after one that I made for His Most Serene of Bavaria, but all retouched by my hand'; 'done by one of my scholars, the whole, however, retouched by my hand'. Elsewhere, Rubens emphasizes that the works he is sending are from his own hand, but notes exceptions such as 'I have engaged, as is my custom, a very skilful man in his pursuit, to finish the landscapes, . . . but as to the rest be assured I have not suffered a living soul to put hand on them'.

Van Dyck, turned master, followed the same methods of mass production. The Earl of Strafford writing to his man of business[1] says, referring to some portraits by Van Dyck: 'The half-pictures (half-lengths) must stand me in £30 a piece and those at length in £50 a piece. But methinks that £20 a piece for the copy of the short and £35 for the larger were sufficient, especially taking so many from him at once and in a dead time also.' Later he adds with reference to two portraits of himself intended as gifts 'and mind Sir

[1] Earl of Birkenhead, *Strafford*, 1938, p. 181.

Anthony that he will take good pains upon the perfecting of this picture with his own pencil'.

Similarly in his vast series of wall and ceiling paintings, we know that G. B. Tiepolo employed assistants, among them his talented son, Domenico. Domenico has a personality of his own, but when working with his father, it is almost impossible to tell where one ends and the other begins. We know nothing about the studio of Canaletto, save that his nephew, Bellotto, worked with him as a young man; but there is a large number of topographical views of Venice which shade from work which has a sensitiveness and unity which only one mind and hand can give, to accomplished but dull and pedestrian work. Where are we to draw the line, and say this is by Canaletto, and that is not?

The work of portrait painters in big practice presents similar difficulties. Lely, Kneller, Sir Joshua Reynolds, all employed 'drapery hands' and assistants. In portrait after portrait, one has to ask how much of this is by the master's own hand; and as often as not, the wise man says he does not know. Quality of work is no sure guide. The work of a skilled assistant may be more dexterous and accomplished than slapdash passages put in by the head of the workshop, especially if that assistant is well schooled in his employer's methods; for even the greatest painters cannot always work on their highest level. On the other hand, great familiarity with a painter's work generally reveals characteristics which belong to him alone, analogous to characteristics in a handwriting. These may not always be agreeable or worthy. They may be tricks, mannerisms, short-cuts, but they are marks of his brush having been at work; and so may enable his work to be separated from that of assistants or collaborators.

The collaborative aspect of the painter's workshop, as outlined above, has had its influence on the language of art historians and connoisseurs. A series of terms has had to be coined, to express in some way the relation of a particular painting to a particular master. The term 'By X' implies that the work is for the most part by the master's hand. 'By X and assistants', suggests considerably more help, though the master plays the dominant part; while 'Studio of X' generally

means that though the conception of the painting is that of X, that he supervised the execution, may have done a limited amount of work on it, and was paid for it, yet the work is largely by other hands. 'School of X', however, implies elimination of X from the work itself, but that the painter of the picture worked under his influence, following him in ideas, conventions, and technical methods. At the same time, some degree of contact with X is implied, though not necessarily that the painter was a pupil of his.[1] In this, the term differs from 'Follower of X' which may well be used of a painter of considerable later date than X, though he has modelled his work on that of X. Distinct, again, is 'Imitator of X' which suggests a more slavish follower, with no independent ideas. This, however, has a different connotation from 'After X', which is used of a copy, with or without variations.

Other terms which may be found in books or catalogues, which have no exact equivalent in English usage, are the German 'Kreis of X', and 'Richtung X'. Kreis (meaning literally 'circle') implies somewhat more regular and close contact with the master than does 'School of X', while the untranslatable Richtung (literally 'direction') means that a painting has some of the characteristics of the work of X, but a considerable amount of individuality.

Unfortunately, there is not and there is never likely to be, complete agreement as to the finer shades of meaning of the terms described above. But that they exist and are in use, emphasizes the variety of ways in which a painting may be inspired, and in the way its production may be brought about.

In the nineteenth century the system of hired workshop assistants virtually disappeared. Even the most fashionable and busy portrait painters, whose work could well have been organized on the lines

---

[1] The word 'school' as used above, differs somewhat from its meaning in such phrases as 'American School', 'French School', and so on, where it amounts to little more than a statement as to where a painter was born, or produced most of his work. Also it differs from its use to describe a group of painters who have similar ideas and methods, as in 'Impressionist School'.

of mass production, usually did all the work on a painting themselves. In the case of large mural paintings (more frequent in the nineteenth century than is usually supposed) assistants would generally be used; but these were engaged *ad hoc*, often from among a painter's pupils or from an art school, and did not form part of a regular organization.[1] However, the system of a painter taking pupils into his studio continued; but these again did not form part of a working team, but came purely for instruction, which was generally conducted on the same lines as in an art school. This more or less complete abandonment of the medieval system is in part traceable, as has been said, to the change in social status of the artist; and gained impetus from the idea fostered by the Romantic movement in the earlier part of the nineteenth century, of a painting being primarily a means of expression for the artist, rather than something made to serve a particular purpose, or to meet the wishes of a patron. This change was facilitated by, and perhaps helped to bring about, the emergence of the 'artist's colourman', who not only prepares colours ready for use, but supplies all kinds of equipment required by the painter. Moreover, the specialized maker of artists' materials can use far more easily than the artist the results of scientific investigations to improve, cheapen, and widen the range of what the artist uses. Thus, the *raison d'être* of the apprentice-pupil and of the paid assistant partly disappeared. Their services in preparing materials for use were not wanted, and they did not need to learn that part of the painter's craft. Spasmodically today, some painters make attempts to revert to the older system, and to prepare their own canvases and panels, make their own varnishes, and so on, but the commercial article saves too much trouble and time for it to be superseded.

An interesting reflection of the change outlined above is in the character of the recipes and instructions used by painters at different periods. Those of the Middle Ages and Renaissance generally give

[1] Probably, the only surviving examples of such are the workshops which produce the paintings for sale in cheap furniture stores, or in shops frequented by tourists in pleasure resorts. One man does water, another hills, another trees, and so on; and the whole painting is pulled together by a 'master painter'.

detailed accounts of how to refine and purify raw materials, such as pigments and varnishes, before any question of how they are to be used is mentioned. The painter was expected to start with a substance in its crude form, and himself put it into condition fit for use. Considerable attention is also given as to what materials the painter may safely use, from the point of view of permanence. Instructions then generally follow as to how to bring those raw materials together into the form required by the painter. This included not only paint and varnishes, but the preparation of walls, panels, and canvases. Only then is the actual process of painting described, often in considerable detail. The whole thing reads much more like an old-fashioned cookery-book, in which the housewife herself has to prepare some of the materials and be responsible for their quality. In later books on painting the emphasis changes. In the seventeenth and eighteenth centuries there is still discussion of raw materials; but these are evidently regarded as more or less standardized in character and quality, and increasing emphasis is laid on the processes and methods of painting, as distinct from preparation of the materials. During the nineteenth century this emphasis is still more marked. It is taken for granted that the manufacturer of artists' materials is in the background. Materials and equipment may be discussed, but primarily from the point of view of how they are to be used and what effects they will yield. Direct control of their character and quality is assumed to be outside the artist's range. At the same time the number of books concerned with the scientific analysis of materials and methods increases, primarily from the point of view of reliability and permanence; while scientific investigation of various phenomena such as light, human anatomy, and geologic structure which may concern the artist, is also put at his service in terms he can understand. This work is done for the artist, and not by him; and is another aspect of the process of specialization already noted, in which painters concentrate on different types of market, and the artist's colourman takes over the business of supplies.

Two consequences of all these changes may be noted. One is the virtual disappearance of a well-established workshop tradition. Prob-

ably, its last survival among painters was among the decorators of carriages, who had established systems of mixing paint and varnish and of applying them, which yielded results not only uniform, but able to endure the usage they had to face. The painter working as an individual has neither the need nor the opportunity to instruct people in his methods. Much casual technical information is no doubt exchanged among painters, or handed on to pupils in a studio or art school; but the systematic and rigid drill called for in an organized workshop can no longer exist, and the modern painter interested in his craft has to rely mainly on his own experiments and investigations.

Turning from the human organization of the workshop to that of arrangement and material equipment, today and yesterday are sharply in contrast in two respects. Before the nineteenth century the bulk of an artist's work was done in the workshop, except, of course, in the case of mural paintings; while in the nineteenth and twentieth centuries the painter, and especially the landscape painter, has come to work much more out of doors. Dürer and Van Dyck might make water-colour sketches 'on the ground'; Claude is said to have made oil sketches during his excursions in the Roman Campagna; but these were the preliminaries to the painting of a picture, not the picture itself. Constable is reputed to have been the first painter to work on a 6-foot canvas in the open air, but he did much subsequent work in his studio. For the impressionists, however, and their followers, the open air was their studio; and even figure-painters may pose models out of doors, and paint directly from them. With this change is probably connected another, that of the lighting arrangements of the studio. From a few examples that survive and from prints, drawings, and paintings representing artists at work, it seems that up to the beginning of the nineteenth century the normal light of a studio was that of an ordinary living room of the period, controlled and directed to light canvas and model as the artist wished (see Pl. IV a). The palatial interiors in which painters have sometimes represented themselves are probably fictitious, designed either to add interest to the

picture or to magnify the artist's importance (cf. Pl. III). Even so, there is no suggestion of any special kind of lighting, and there is no reason to doubt the literal accuracy of the seventeenth-century Dutch paintings which represent Dutch studios. In contrast, the nineteenth-century painter demanded a top light, either from a sky-light or very high windows (Pl. V). This gave him a light from the sky, approximating to that of out of doors, and made easier the carrying forward of work planned and begun in the open air, or of painting in a way that simulated work done out of doors.

Working direct from nature in the open air was paralleled in the nineteenth century by the extension of the practice of working direct on to the canvas from models in the studio, with less use of drawings and preparatory studies than was usual in earlier times. This demanded a light which varied as little as possible, if the painter was not to be continuously interrupted by changes in light; and so came the de-mand for light coming not only direct from the sky to avoid reflec-tions from neighbouring buildings, but from the north. Hence, to the nineteenth century we owe the extensions of private houses and the blocks of studios, whose lighting satisfies conditions which have come to be regarded as necessary for a painter.

The equipment of a painter's workshop has changed with its organization. Broadly, the whole apparatus for the preparation of pigments, media, and varnishes has disappeared. It would be difficult to find today a painter who owned, much less used, the stone slab and muller (another stone held in the hand with a flat surface which moved against the slab) which was used to grind pigments to powder and to incorporate them into the medium with which they were mixed, and which appears in many representations of the interiors of earlier artists' workshops (Pls. I, II, IV a). Again, the modern painter does not need the pestle and mortar to break up crude sub-stances, preparatory to the various processes of refining them, nor the array of beakers, pipkins, crucibles, and other vessels, or the stoves and ovens, which were used in preparing oils and varnishes. One interesting result of this change is the different way in which the paint resulting from the mixture of pigment and medium is treated.

In the earliest representations of the workshop the presence of a number of small pots near the painter suggests that the paint went straight from the slab and muller into these, ready for use (Pl. I *a*). Later, though the paint was still prepared in the studio, they were put in little bags of skin, which would be reasonably air-tight, and keep the mixed pigment from hardening for a time. Examples of these appear in a still life by Chardin of a painter's equipment (Pl. II), and may still be seen occasionally in museums. Finally, when the preparation of paint passed to the artist's colourmen, and it became necessary to prevent deterioration for as long as possible, the metal tube of today, with the screw cap, came into use, apparently in the late eighteenth or early nineteenth century. Again, there is no evidence that the work involved in making panels and the wooden frames (stretchers) on which canvas is stretched, was done anywhere but in the painter's own workshop; and there is plenty of evidence that the application to canvas and panel of a ground of suitable surface and consistency to be painted upon, was entirely the painter's responsibility.

Thus the laboratory and manufacturing apparatus once customary in a painter's workshop is no longer there. Here and there relics of earlier practices survive. Exceptionally, modern painters may be found who themselves fasten a piece of canvas to its stretcher, and prepare their own grounds on panel and canvas, though the materials are likely to be bought ready for use, and the motive to be economy rather than necessity. Also, older practice sometimes survives in the use of egg tempera (of which a detailed description is given later) when the artist himself mixes powder colour with yolk from eggs broken by himself, and incorporates one with the other on a glass slab with a small glass muller. In recent years, however, colours ready ground in a tempera medium can be bought in a shop.

Yet the tradition of the man who is to use the materials also making them has to some extent revived in the case of first-rate restorers of paintings. With the desire to use only materials for whose behaviour they can answer, such men sometimes grind and purify their own pigments, prepare their own mediums and varnishes, while in such

operations as transferring a painting to a new panel they will themselves select, shape, and prepare the panel.

When, however, it comes to the implements used in painting a picture, changes have been small. The type of easel on which the panel or canvas is supported in a more or less upright position, is as old as the history of painting. This has three legs, two in front and one behind, in the two front legs being a series of holes into which pegs are inserted on which the painting rests. The third leg is hinged, so that the angle at which the easel stands can be altered, and the whole thing folded up (Pls. I a and IV a).[1] In the nineteenth century the 'studio easel' was introduced, basically consisting of two uprights on a base which is mounted on castors. The *palette*, on which the colours are arranged to be mixed and taken up by the brush or other instrument, has also changed little.[2] It may be oval or rectangular, with variations on these basic shapes, and is pierced with a hole for the thumb (Pl. II). The standard material is and always has been wood, though the nineteenth century has introduced the use of porcelain (mainly for water-colour and tempera painting) and enamelled metal, both often with indented cups to hold the colours. For studio work, however, some painters prefer, like their predecessors, to use a table standing by their side, whose top serves as a palette. Brushes, again, are essentially the same as they were. In the West they seem always to have been made of animal hair, and fall into two types of hard and soft. The harder, stiffer type have long been made of hog bristles; the softer ones, used for fine work in oil and generally in water-colour painting, are usually made from sable and from the so-called 'camel' hair (usually squirrel), though other hairs may be employed, as they were in the fourteenth and fifteenth centuries. The shapes and sizes of the brushes vary according to the

---

[1] A minor mystery is the absence of this third leg from the easel in Plate I b, or of any apparent means of keeping the easel upright. Perhaps the piece of wood seen at the top was secured to a beam.

[2] It should be noticed that sometimes the term palette is used, not of the surface on which the paints are placed and mixed but of the colours used by the painter and the way he arranges them for use. Thus, a 'restricted palette' means that few colours are employed.

painter's needs. The only substantial difference in this respect between those of the past and of today, is that in the nineteenth century metal ferrules came into use, which made the making of flat brushes easier; while the brushes represented in paintings before 1800 are invariably round (cf. Pl. II).

One piece of equipment of the earlier painters, the *mahlstick*, consists of a stick with a knob at the end, generally covered with soft leather, which could be rested against the painting, and serve as a support for the artist's wrist, especially when precision of touch was required. Its method of employment is clearly seen in the studio interior by Adriaen van Ostade (Pl. IV *a*). Its use is rare now, but still continues among restorers of paintings. Palette knives and various forms of spatula on the other hand, seem to have been in continuous use. The modern *palette knife* is usually a narrow flexible blade, without a cutting edge, used to mix paint on the palette, and sometimes to apply it to the painting. It gives a denser quality of surface to paint, quite distinct from that of paint applied with a brush, or it can be used to obtain sharp accents by heavy loading of the paint. In its systematic use for the latter purpose, Turner and Constable were pioneers. During the eighteenth century and earlier, the knife seems to have been a broader and heavier instrument, used to remove pigment from the grinding slab, and to mix on palette or table pigments thus prepared. Such knives, or rather spatulas, were also used to apply preparations to panel, canvas, and wall, but whether they were used in the process of painting is uncertain.

Another group of materials whose presence in the workshop has been continuous, are those for drawing, including paper, various kinds of metal, chalks of different colours, ink, and pens of different types. The most notable difference between today and earlier times is due to the development in the nineteenth century of encasing chalks in wood and of the wood-encased graphite universally known as a 'pencil'.[1] Before then, the various materials were put into a holder, such as appears in the painting by Chardin (Pl. II).

---

[1] Before the nineteenth century, and later in poetic usage, the term 'pencil' was applied to a painter's brush, and unless this is realized, confusion may arise (Cf. line 2, p. 17).

Aids in selecting a landscape composition and in making drawings, especially of architectural subjects, are the Claude glass and the camera obscura. These are seldom used today, but are often spoken of in accounts of seventeenth-, eighteenth- and nineteenth-century painting. The *Claude glass* (which takes its name from the painter Claude Lorrain, who is said to have used one) is a black convex glass, which reflects a view in miniature, largely eliminating colour and detail, thereby enabling suitability as a subject to be more easily judged than otherwise. The *camera obscura*, by means of a lens and mirror arranged in a box, throws a diminished reproduction of a view on to a piece of material on which it can be traced. Both Canaletto and Bellotto, the eighteenth-century Venetian topographers, are reputed to have used such a device, and Girtin, for a series of etchings of architectural subjects, certainly did so. The *camera lucida* is a nine-teenth-century development of the camera obscura, in which a prism is used instead of a lens to throw the image on to the paper. Today it is mainly used in connexion with microscope work.

A piece of studio furniture which has been regularly in use, is the paint-box or storage cabinet. Until the nineteenth century and the invention of metal tubes to hold paint, this was usually a capacious and elaborate affair, large enough to hold prepared pigments, mediums, vessels for mixing, and so on. A seventeenth-century example with three drawers, and decorated with small paintings by A. J. Croos, may be seen in the Rijks Museum, Amsterdam. A more splendid affair, now disappeared, but known from a description,[1] was owned by Richard Wilson. This was a model in wood of the Piazza in Covent Garden (where Wilson's studio was). This was about 6 feet high, in which the rusticated work of the piers was divided into drawers, while the openings of the arches held brushes and oil bottles.

Another group of objects whose appearance in the workshop has been more fitful, are casts from sculpture, human skeletons, objects used as models, manikins, and lay figures (cf. Pl. III). Casts, especially from the antique, were a regular part of workshop equipment in

[1] By J. T. Smith, in *Nollekens and His Times*.

the sixteenth, seventeenth, and eighteenth centuries. One is seen in the already cited Chardin still life. Partly this was due to the importance attached to a knowledge of classical antiquity, partly to the presence of pupils in the studio who had to be trained in 'drawing from the antique'. The human skeleton and the human bones which occasionally appear in views of studio interiors were likewise mainly used for teaching purposes. Today, such casts and anatomical specimens are more common in art schools than in artists' studios. Draperies, armour, metal and pottery utensils to be used as accessories or for still-life painting, also come and go according to the tastes of the time and the kind of painting the artist is engaged upon. Manikins, small jointed figures of the same proportions as the human figure, appear at least as early as the sixteenth century, and were used as a basis for drapery arrangements in the absence of a living model. In the nineteenth century the *lay figure*, as it is called, became more usual and was used for the same purpose. This is usually life-size, is more elaborately jointed than the manikin, and more closely resembles the human figure. In the twentieth century, however, it has fallen into disuse.

A major difference between the nineteenth-century painter's equipment, and that of earlier periods, is due to increased work out of doors. The portable colour-box, apparently first used by the early water-colour painters, now holds material for oil painting;[1] and to this have been added the portable easel, the camp stool, and various means of shading the painter from the sun or protecting him from rain, such as the sketching umbrella (cf. Pl. IV *b*). In nineteenth-century humorous drawing, indeed, these articles became regarded as the chief means to identify an artist.

[1] A term sometimes met with is *pochade box*, used of a small colour-box, with panels fitted into the lid, on which quick sketches can be made.

# 3

## THE PHYSICAL STRUCTURE
## OF A PAINTING[1]

WHATEVER materials and processes may go to their making, all paintings are essentially the same in physical construction. Each is composed of a series of layers which, in the most elaborate form and moving from back to front, consist of (1) the support, (2) the ground, (3) the priming, (4) the paint layer, (5) a protective coating. This construction is illustrated in Plate VIa, a drawing made from a photomicrograph of a fifteenth-century painting on top of which a modern forgery had been made. The support (not shown) was of old wood. On top of this was a thick ground of old gesso (plaster of Paris and size), on which in turn was a layer of paint, covered with a thin layer of varnish. The forger began work with another layer of gesso, on which he put his paint layer. Over this he had put a thick varnish, not illustrated here since it had been removed to permit examination. The character of each layer in a painting and the way they are combined one with another, affects in varying degrees both the appearance of the painting and its permanence under different conditions. Since the number of layers may vary, and since each layer can be composed of a wide range of substances, it is easy to see that the number of possible combinations is very large, with a corresponding possibility of differences among paintings when completed. Some knowledge, therefore, of the layers of which a painting may be made up, is important for understanding why the final result of a painter's work is what it is.

[1] The following chapter will probably be found dull reading. It is, however, short, and if the reader will persevere, he will find it useful for understanding what follows.

*The Support.* As its name indicates, this is the material that mainly holds a painting together. The only limits (and these are elastic) set to what that material may be, are (1) that it is strong enough to serve its principal purpose; (2) that it is suitable for the ground or for the paint layer which it is to carry—a metal support, for example, would probably not be chosen for a pastel; (3) that it suits the purpose for which the painting is being made. Thus, sheets of vellum sewn together would hardly be a practical support for a 6-foot portrait. So supports have included paper and millboard in various forms; vellum; leather; all kinds of textiles, among them canvas, linen, and silk; various metals, notably copper and zinc; all kinds of wood; glass; stone of different types; walls, including those of stone, brick, and plaster; while in recent years have been added composition boards of various kinds. Sometimes two or more materials may be united to form a support. The most obvious example is the case of brick or stone walls, whose surface may be so irregular that a facing of some other substance such as wood, canvas, or plaster is necessary before the ground can be applied. By changing the nature of the material on which the ground is laid, the influence of the original support on the appearance of the painting may be negatived, but it may still affect the permanence of the picture, and so must be taken into account in any estimate of why changes have occurred in a painting. For example, canvas applied to a wall may be affected by movements in the wall, or by damp coming through the wall. Again, a support may be strengthened by being backed with another material. A painting on paper, vellum, or a textile may be mounted on a wooden panel; and canvas is sometimes fastened to millboard, to make what is called by artists' colourmen 'canvas board'. In such cases, the reinforcing material may well become a cause of changes in the painting. A panel may warp or split, and tear the material mounted upon it; millboard may decay or discolour, and stain the canvas attached to its surface.

*The Ground.* Sometimes the surface of the support is such that the paint layer cannot conveniently be applied to it direct. It may be so rough that delicacy and precision become impossible, and irregularities cause disturbing shadows on the paint surface; it may be so

smooth or so dense in substance that the paint layer will not adhere satisfactorily; it may be so absorbent that it is difficult to lay the paint upon it; or it may contain substances such that undesirable reactions may take place between it and the paint layer. It is the business of the ground to adhere firmly to the support, to act as a buffer between it and the paint layer, and to provide a surface and consistency suitable for the reception of the paint layer. It follows that grounds vary widely, according to the nature of the support and the kind of medium with which the pigment is mixed to form the paint. Since various types of ground are described in the chapters devoted to different processes of painting, there is no need to describe them in detail here. It should be realized, however, that a ground is not necessarily uniform, but may be composed of a series of layers of somewhat different composition. Also, the ground is not an indispensable element in a painting, since in some cases the paint can be applied direct to the support.

*The Priming*. This is sometimes confused with the ground. In fact, it is properly a thin layer applied to the ground to make it more suitable to receive the paint layer. For example, a ground may be too absorbent for the painter's purpose, and the priming be used to make it less so. In such cases, the medium with which the pigment is mixed is often employed. The term priming is often used of a similar thin layer applied to the support, to prepare it for the paint layer when it is proposed to paint directly upon this. In this case, however, it is more in the nature of a ground, and serves the same purpose.

*The Paint Layer*. This almost invariably consists of a *pigment*, in more or less fine states of subdivision, held in suspension in a medium. Occasionally cases are known of dyestuffs being dissolved in a medium, and being used to stain a surface. Usually, however, dyes are precipitated on to some inert substance (aluminium hydrate is often used), the product then being ground up and incorporated in a medium. Some of the most famous colours used by painters, such as crimson lake and rose madder, are prepared in this way. The hue and brightness of colour in a painting depends on the extent to which it absorbs some of the component elements of white light and reflects

PLATE I

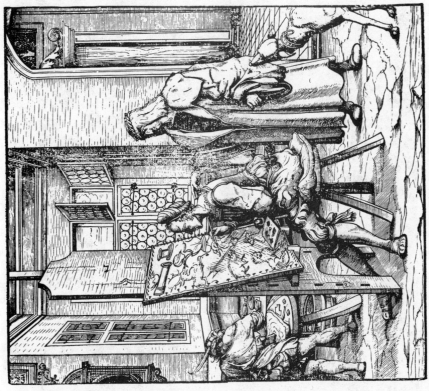

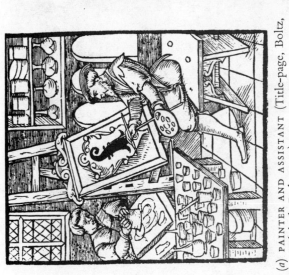

(a) PAINTER AND ASSISTANT (Title-page, Boltz, *Fahrbuch*, Basle, 1549)
*Victoria and Albert Museum. Crown Copyright*

(b) THE EMPEROR MAXIMILIAN IN THE ARTIST'S WORKSHOP (from the *Weisskunig*, 1514-16, by Hans Burgmair)

PLATE II

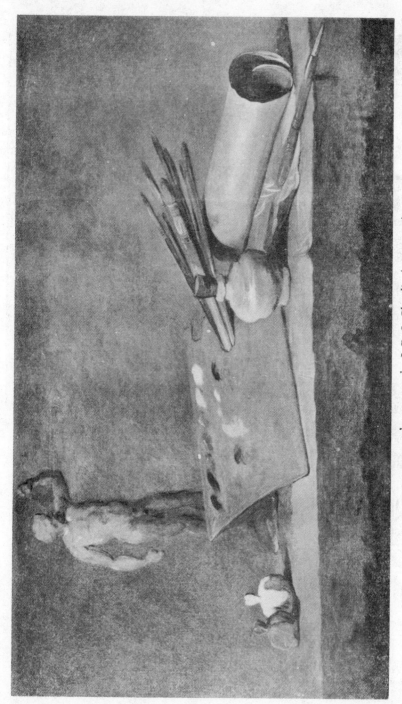

THE PAINTER'S TOOLS, by J. B. S. Chardin (1699–1779)
*Princeton University*

PLATE III

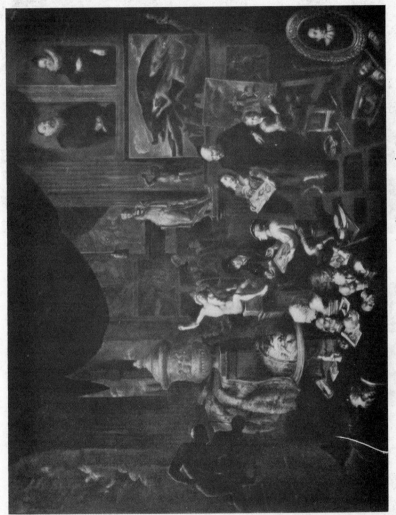

ARTIST AND PUPILS. Flemish School, Seventeenth Century

*Doria Palace, Rome (Photo. Fratelli Alinari)*

PLATE IV

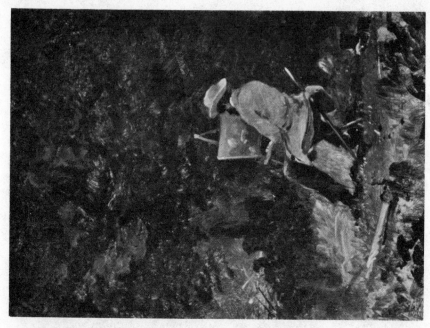

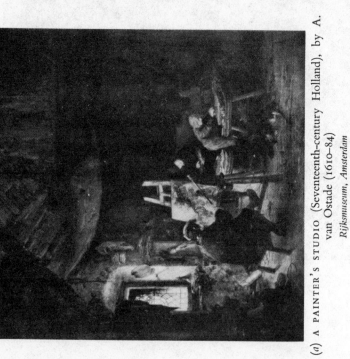

(a) A PAINTER'S STUDIO (Seventeenth-century Holland), by A. van Ostade (1610–84)
*Rijksmuseum, Amsterdam*

(b) THE ARTIST SKETCHING, by W. S. Mount (1807–68)
*Victor Spark, New York*

PLATE V

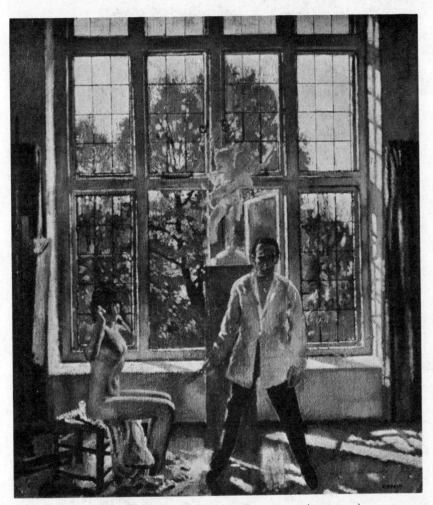

ARTIST AND MODEL, by Sir William Orpen (1878–1931)
*Museum of Fine Arts, Boston*

PLATE VI

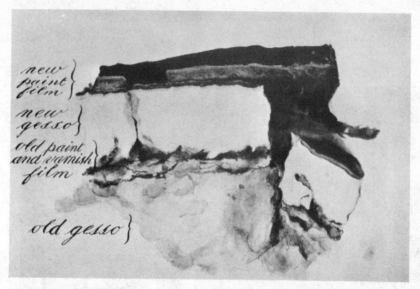

*(a)* LAYERS OF A PAINTING. Fifteenth-century work used as a basis for a modern forgery

*(b)* YELLOW OCHRE (magnification 105)

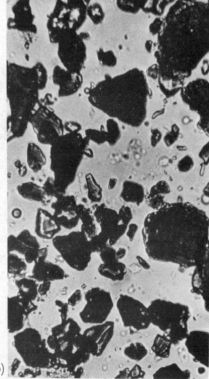

*(c)* AZURITE (magnification 300)

PLATE VII

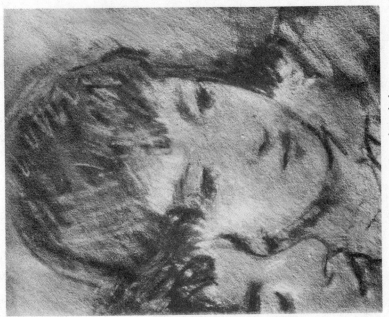

(b) PASTEL, by raking light.
Detail from *Two Girls*, by Mary Cassatt (1845–1926)
*Museum of Fine Arts, Boston*

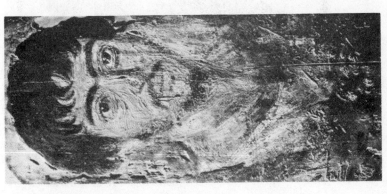

(a) ENCAUSTIC PAINTING, by raking light.
*Fayoum Portrait of a Man* (Second Century A.D.)
*Museum of Fine Arts, Boston*

PLATE VIII

WATER-COLOUR

*View on the Venetian Lagoon.* Washed Drawing by Antonio Canale, called Canaletto (1697–1768)

*Museum of Fine Arts, Boston*

PLATE IX

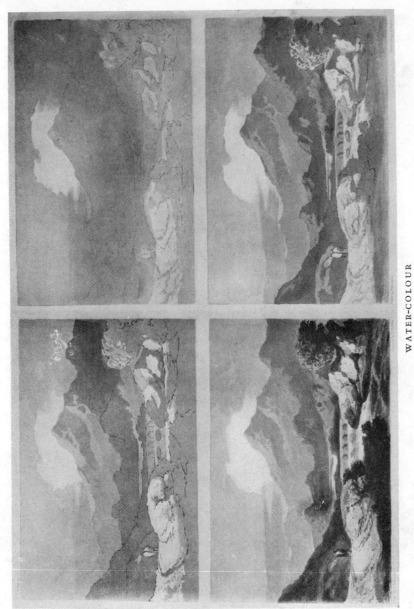

WATER-COLOUR

Stages in early practice (from F. Nicholson, *Practice of Drawing and Painting Landscape*, 1820)

PLATE X

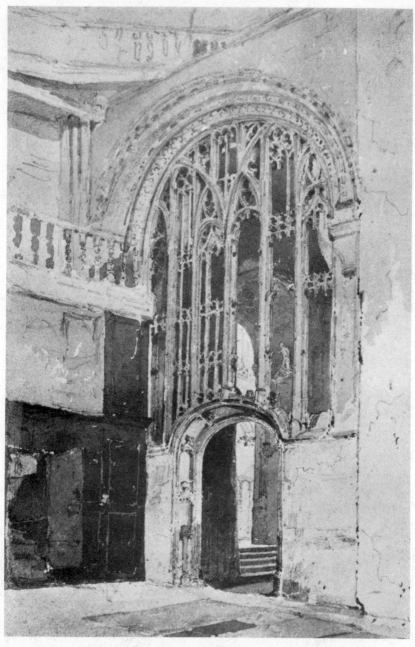

WATER-COLOUR
*Screen in Norwich Cathedral,* by J. S. Cotman (1782–1842)
*Sir Edmund Bacon, Bt.*

PLATE XI

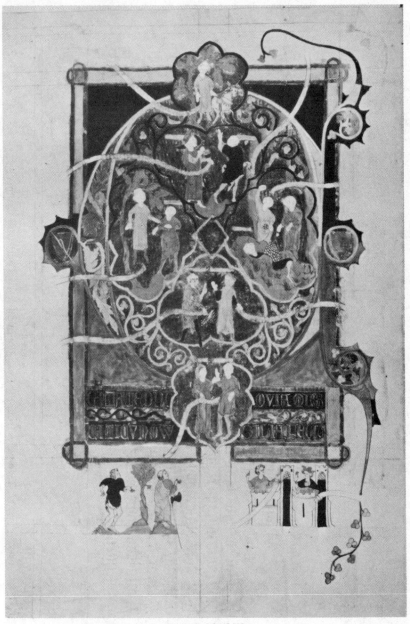

WATER-COLOUR

Page from the Tickhill Psalter (fol. 104ʳ) (Fourteenth Century)

*Spencer Collection, New York Public Library*

PLATE XII

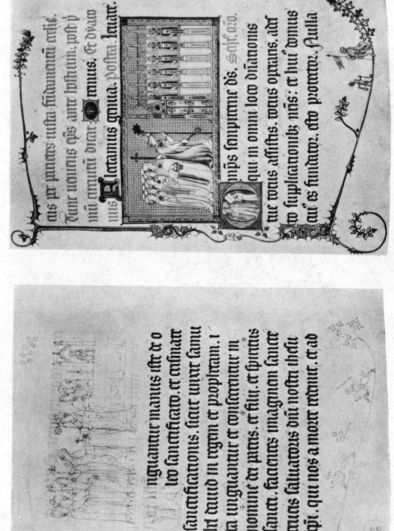

WATER-COLOUR

Two pages from the Metz Pontifical (early Fourteenth Century)

*Reproduced by permission of the Syndics of the Fitzwilliam Museum, Cambridge*

PLATE XIII

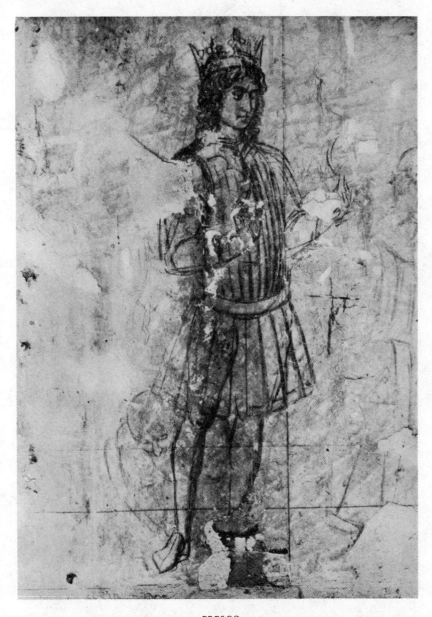

FRESCO

A King, from an *Adoration of the Magi* (Italian Fifteenth Century). Underlying drawing

*Camposanto, Pisa*

PLATE XIV

FRESCO
(a) *St. Paul and St. Peter*, by Correggio (c. 1494–1534)
*S. Giovanni, Parma*

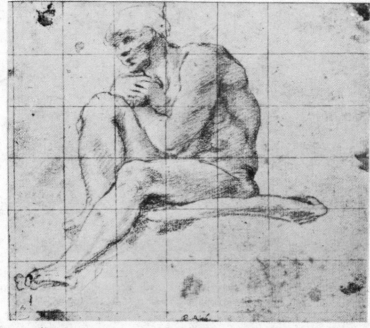

(b) STUDY FOR ST. PAUL (red chalk, squared up) by Correggio
*Albertina, Vienna*

PLATE XVII

(a) OIL PAINTING

Adoration of the Magi (detail) by Leonardo da Vinci
(1452–1519). Unfinished
Uffizi Gallery, Florence (Photo. Fratelli Alinari)

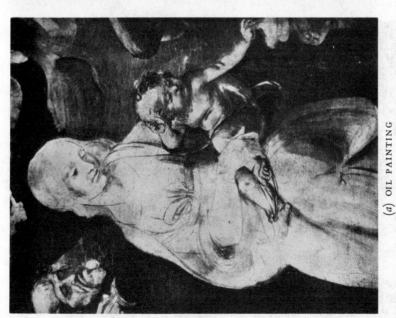

(b) OIL PAINTING

Holy Family, attributed to Pierino del Vaga (1501–47).
Unfinished
Courtauld Institute, London

PLATE XVIII

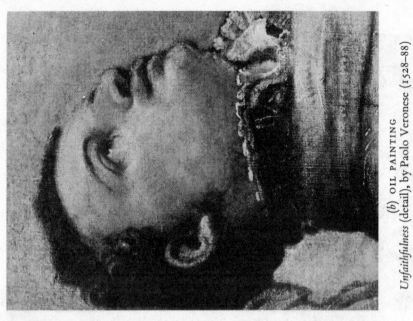

(b) OIL PAINTING
*Unfaithfulness* (detail), by Paolo Veronese (1528–88)
*National Gallery, London*

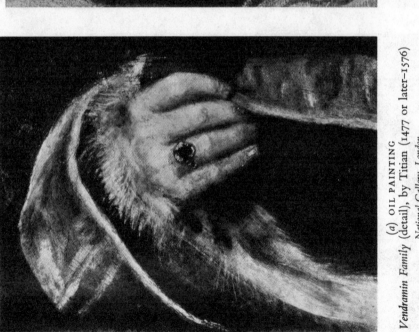

(a) OIL PAINTING
*Vendramin Family* (detail), by Titian (1477 or later–1576)
*National Gallery, London*

PLATE XIX

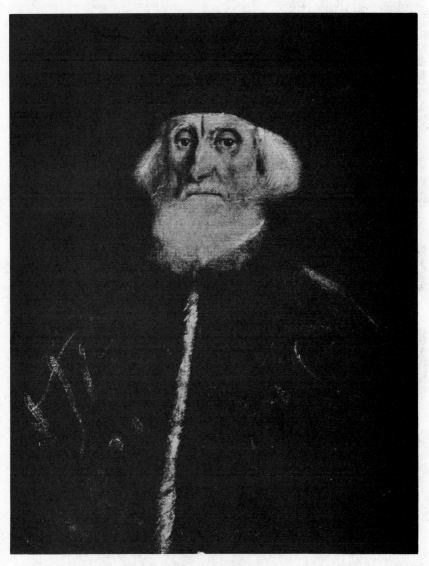

OIL PAINTING
*An Elderly Man*, by Tintoretto (1518–94)
*Castello Sforzesco, Milan*

PLATE XX

(b) Enlarged detail of the face

(a) Enlarged detail of a feather

OIL PAINTING

*Chapeau de Paille*, by Rubens (1577–1640)

*National Gallery, London*

PLATE XXI

OIL PAINTING
*Woman Bathing* (detail), by Rembrandt (1606–69)
*National Gallery, London*

PLATE XXII

(b) Detail by raking light

(a) Detail

OIL PAINTING
*Rouen Cathedral* (detail), by Claude Monet (1840–1926)
*Museum of Fine Arts, Boston*

PLATE XXIII

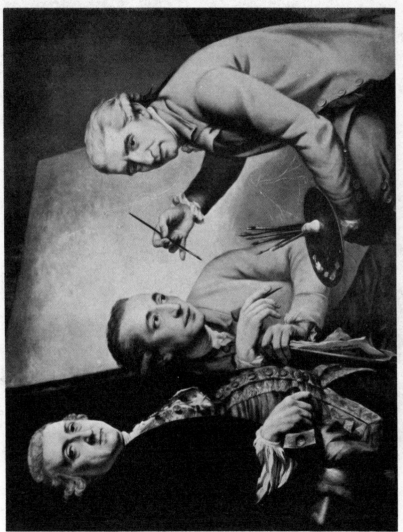

*Carlini at work, with Bartolozzi and Cipriani, by J. F. Rigaud (1742–1810)*
National Portrait Gallery, London

PLATE XXIV

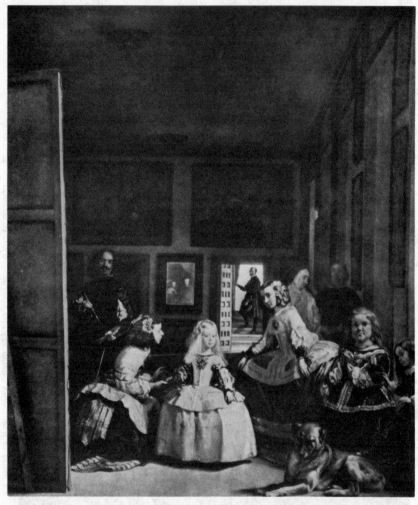

LAS MENIÑAS (*The Ladies in Waiting*), by Velazquez (1599–1660)
*Prado, Madrid*

others back to the eye. Thus if it absorbs all the reds and yellows, but reflects the blues, it will appear blue. The size and the shape of the grains of pigment are among the factors that determine the amount and character of the absorption and reflection, and some pigments (e.g. azurite, a blue copper carbonate), if ground too small, lose their colour because too much white light is reflected. To illustrate how different these grains of pigment may be, two micro-photographs of two different pigments are contrasted on Plate VI *b* and *c*. Yellow ochre (*b*) which is a natural earth coloured by iron oxide, is revealed as a mixture of very small, almost colourless particles, and larger dark ones of almost the same shape; azurite (*c*) is seen to have the marked crystalline form, with the coarse texture necessary to preserve its colour.

Pigments used in painting may be classified in several ways, which vary according to the purpose the classification is to serve. Groupings which in varying ways and in varying degrees concern the painter and the student of painting are those based on chemical composition; the source from which the pigment is derived; its use in history; and its colour.

1. *Chemical Composition.* Here, an important distinction is that between organic and inorganic pigments. The organic are those composed of carbon with various other elements, and include the madders, carmine, crimson lake, gamboge, indigo, and the various colours derived from coal tar. The inorganic pigments include those derived from the combination of various substances with metals to form oxides, sulphides, and so on; examples being red and yellow ochre, true ultramarine blue (made from lapis lazuli), *terre verte* (the French form of the Italian *terra verde* = green earth), vermilion, and green oxide of chromium (generally called viridian). The importance of chemical composition is that it helps to determine the permanence of a pigment when used in painting. The ideal pigment for painting should be both stable (i.e. should not change when exposed to influences which are potentially disintegrating) and inert (i.e. if mixed with other substances, chemical action between the two should not be set up). Stability and inertness, however, only have to be considered in relation to the treatment a painting is likely to

receive. Extreme heat, or contact with strong acids or alkalis is not a normal risk. On the other hand, light, air, and moisture, to all of which a painting is ordinarily exposed, can either singly or in combination change the character of a pigment. For example, very few of the organic pigments are stable, and light alone may cause them to fade, while light and moisture together are still more potent. The oxygen in the air may itself combine with certain elements in a pigment, and cause discoloration. Air, however, is also likely to contain moisture, as well as impurities such as sulphur dioxide and sulphide of hydrogen; and some of the pigments based on chromium (such as chrome yellow), red lead, and Prussian blue are then peculiarly susceptible to its action. Attention, too, has to be paid to the mixture of pigments. Thus, sulphide pigments (e.g. cadmium yellow) may interact with copper and lead pigments (such as emerald green or red lead) to produce a black sulphide. Similarly, the chromates (e.g. chrome yellow) may lose their oxygen to various organic pigments with which they might be mixed (e.g. rose madder, crimson lake), causing both to lose their colour. Lastly, the nature of the pigment itself has to be taken into account. Asphaltum (or bitumen, as it is sometimes called), which is a tarry organic brown pigment, much used in English eighteenth-century paintings, never completely hardens, so that it develops broad cracks and in its movement is likely also to injure paint layers above or below it.

It should, however, be noted, as will be seen later, that the composition of the pigment is not the only factor in permanence, which also depends on the character of the medium used and on its ability to protect the pigment. Clearly, however, some knowledge of chemical composition will help the painter to safeguard his work against change, and will help the student of a painting to discover why a colour today, or some area of paint, does not look today as the painter intended it to look.[1]

---

[1] For succinct and precise information on chemical composition, and its influence, see Gettens and Stout, *Painting Materials* (section 'Pigments'). Other books which may be consulted are Church, *The Chemistry of Paints and Painting*, London, 1915; and De Wild, *The Scientific Examination of Pictures*, London, 1929.

2. *Source of Derivation*. Classification on this basis to some extent cuts across that on the basis of chemical composition. Thus, inorganic pigments are for the most part found in a natural state, in form of earths and metals, though they may equally well be artificial, made by a process of chemical synthesis. Natural sources also provide many of the organic pigments, but, unlike the inorganic, these may come from animals, as do carmine and crimson lake (from the cochineal insect) and sepia (from the cuttle-fish), or from plants, as do the madders, indigo, and gamboge, while, like inorganic pigments, they may be manufactured. This method of classification has some importance for the painter, since pigments derived from natural sources almost always need treatment to free them from impurities, such as washing, levigating, or chemical treatment. In earlier days this was done by the painter himself, and it was the abandonment of this part of a painter's work which helped the emergence of the professional colour-maker. This classification also has some interest for the student of art history. Early methods of purification were unlikely always to be effective, and so pigments used by earlier painters were less likely to be standardized in composition than they are today, and may not be exactly the same as modern pigments of the same name. This in turn may help to account for differences in colour among different painters, or differences in the way a colour has changed.

3. *Historical Use*. Classification on this basis reveals that some pigments, both organic and inorganic, and both natural and artificial, have been used continuously from early days in the history of painting. Examples are carbon black, the coloured earths, such as red and yellow ochre, metallic natural compounds such as cinnabar (the natural state of vermilion) and lapis lazuli (ultramarine blue), preparations of madder and of sap green (from the buckthorn), together with artificially prepared white lead (carbonate of lead, often called flake white), red lead (oxide of lead), and verdigris (acetate or carbonate of copper). Some pigments much used in the past, however, have now practically gone out of use, such as natural orpiment (yellow sulphide of arsenic), malachite (green copper carbonate), azurite (blue copper carbonate), and artificially prepared Egyptian

blue. Again, some natural pigments have come into use comparatively late, notably those based on a derivative from the cochineal insect, brought to Europe from central and southern America after the discovery of those countries. Much more important, however, has been the development in making synthetic pigments. In 1704 Prussian blue was first made, and at the end of the century various other pigments appeared, ushering in the discovery of cobalt blue in 1802, and the making of various pigments based upon zinc, chromium, and cadmium, which included a wide range of yellows. In 1856 the discovery of coal tar dyestuffs and the rapid growth in their manufacture, promised a whole new set of pigments derived from their precipitation on an inert base, but in practice they have proved too impermanent to be useful. The twentieth century has also produced a number of new pigments, among them titanium white. These discoveries have not necessarily greatly increased the number of colours at the painter's disposal. Their tendency has been to displace the natural by the artificial product which is more standardized in quality, is less liable to contain accidental impurities, and is cheaper. Thus, true ultramarine has been virtually displaced by synthetic (called French) ultramarine; and among natural pigments, azurite, malachite, orpiment, and among artificial, verdigris have gone out of use, though a preparation of verdigris (emerald green) is still used.

Historical knowledge as to when pigments came into use is not likely to be of much service to a painter. But to the student of art history it may be invaluable. It may, for example, be decisive in dating a picture and determining its authenticity. Combined with chemical or spectrographic analysis to ascertain what pigments in fact are present in a painting, it can give certain proof that it cannot be before a certain date. A so-called Velazquez in which Prussian blue (invented 1704) is present, certainly cannot be by him; while the presence of large areas of titanium white (invented in the twentieth century) disposes of the claim that a portrait was painted in fifteenth-century Florence.

4. *Classification by Colour.* That this is the essential method for the painter is recognized in the fact that practically all manuals of paint-

ing practice, and most books concerned with pigments, arrange the pigments on this basis. The painter wants to know (or should want to know) what pigments are available for his use, and their characteristics; and the easiest way for him to find out is to look under headings such as 'reds', 'blues', 'greens', &c. Such knowledge, derived from books or oral tradition, enables him to select his 'palette', i.e. the colours he requires for his purposes. Classification by colour is also useful for the art historian, since he is most likely to start his inquiries about the colour of a picture from a specific colour; and it is convenient therefore to find all of (say) the blue pigments brought together with an account of their chemical composition, historical use, &c., in one place.

The *medium* is usually mixed with the pigment before application to the ground. But exceptionally, as in fresco painting (which will be described later), the medium is first applied and the pigment afterwards, this being absorbed into the medium while it is wet, while even more exceptionally, the pigment might be applied first and the medium later, an example being the fixative that is sometimes sprayed on pastel, to bind it more firmly to the ground. While the main purpose of the medium is to hold the pigment in suspension over the ground, it also has considerable influence on the pigment's permanence. The more securely and completely it encloses the grains of pigment, and in proportion to its own resistant power, the less light and particularly air and moisture, or a combination of all three, are likely to attack a pigment, and the less likely is there to be interaction among two or more pigments. Also, the medium may materially affect the appearance of a painting. It can influence the extent to which the pigment absorbs and reflects light, and so the colour.[1] Some pigments become more transparent in certain media than in others, and so reflect less light and appear darker. *Terre verte*, for example, is more transparent in oil than in tempera. Again, if more than a certain amount of a medium is mixed with certain pigments, it affects their transparency and so their colour.

[1] In technical terms 'The higher the refractive index of the pigment and the lower that of the vehicle, the greater the light reflection' (Gettens and Stout, *Painting Materials*, p. 144).

The thickness of the medium also affects appearance. Thick, heavy mediums allow the paint to be loaded on, to form what is known as an *impasto*, and by varying the thickness of the paint in different parts of the painting an artist can give emphasis, and in the loaded passages, density and richness. To obtain variations in thickness of paint, what is known as a *diluent* is usually employed. This is often confused with the medium. The purpose of the diluent, as its name denotes, is to dilute the medium, so that the paint layer can be more easily applied, or can be made of a different consistency. The diluent is such that it will evaporate, leaving no film or layer of its own. Examples are turpentine used with oil, and water with tempera.

One point needs emphasis. The paint layer, like the ground, is not necessarily uniform. In fact, in the great majority of cases it consists of a series of layers, which may differ in the medium employed and the pigments used, forming a very complex structure.

*The Protective Coating.* The medium of the paint layer is sometimes sufficiently hard and tough adequately to resist the effects of moisture, deleterious gases in the atmosphere, or of rubbing, vibration, and even blows. More usually, a protective layer has to be used. Ideally, this should be completely transparent, contain no substance likely to damage the paint layer, and be easily removable so that if damaged it can be taken off and replaced.

Sometimes the protective coating serves as more than a protection and penetrates into the paint layer so that it serves in part as a medium. An example is in oil painting, where only a little medium has been used and much diluent. When the medium has hardened, the pigment may be incompletely enclosed, and the paint surface be dull; a coat of varnish will partly penetrate the paint layer, and help to bind it more firmly together, and also make it more transparent and darker in colour. It is because of this penetration of the paint layer that in the case of certain processes, such as pastel and water-colour, a protective coating cannot be applied, without affecting the reflecting power of the pigment particles by making them more translucent and so darkening the colour.

The protective coating, like other layers, does not necessarily con-

sist of one material only. A layer of one may be superimposed on another, as when a coating of wax is applied to the surface varnish of a painting.

.      .      .      .      .

The structure described above of five layers, each one again perhaps composed of further layers, is that of the most elaborate type of painting. The only layers that are indispensable, however, are the support and the paint layer. Some paintings consist of these only, others of three or four, instead of the full five layers. This fact provides a very convenient basis for classifying and describing various processes of painting. Those concerned with the simplest types naturally involve the least number of operations; and consideration of these leads on to that of the more complicated types and of how they are constructed.

# 4

## PAINTING PROCESSES: WAX;
## PASTEL; WATER-COLOUR

OF the painting processes which require only support and paint layer, the most important and widely used are wax painting, pastel, and water-colour. Two points should be noted: (1) that sometimes other layers may be introduced, such as a ground or a protective coating; (2) that the support sometimes has to be treated to modify its texture, and to make it more suitable to receive the paint layer. Though in fact this introduces a layer between support and paint layer, it is not strictly the introduction of a ground, but rather should be regarded as a modification of the support.

*Wax Painting* is sometimes known as encaustic, from the Greek word 'to burn in'. This has reference to the application of heat to the picture after it has been painted, as described below. The process has the distinction of being among the oldest of the Christian era of which early examples survive. The most remarkable of these are the portraits discovered in the cemetery at Hawara, in the Fayoum in Egypt, which range in date from the century before Christ to the third century A.D. or later. An aperture was cut in the outer casing of the mummy, and behind this a portrait of the deceased was placed. These are painted in wax directly on to a wood panel. The exact process is not known, but it seems highly probable that the pigments were first mixed with wax melted by heat, and were applied to the panel with some form of brush. They were then probably worked over with heated metal instruments, known as *cauteria* (derived from the Greek, like encaustic), the panel probably being kept warm during

the process. This would help to fix the paint layer more firmly to the support, bind together two or more layers of paint, and allow modifications of surface texture. Pliny (in his *Natural History*, written *c.* A.D. 70) also refers to the use of pigment mixed with wax by means of a heated spatula, or of a brush and paint kept liquid by heat. A man's portrait from the Fayoum (Pl. VII *a*) taken by raking light illustrates the technique and surface quality of these encaustic paintings.

That the use of wax in this way was to some extent continued, is suggested by a phrase in a manuscript in the Cathedral Library at Lucca, claimed to date from the eighth century, which in connexion with painting operations says, 'on wood the colours being mixed with wax'. But the use of wax as a sole or principal constituent of a medium applied with the aid of heat fell into almost complete disuse until the present day, though occasional attempts were made to revive it. Among these was that of the Comte de Caylus, who invented a method of painting in water-colour on a wax ground, and of then heating the picture so that the wax enclosed the pigments. He exhibited a painting in the Paris Salon of 1754 made in this way; but the process was never of practical importance.

Wax as part constituent of a medium appears intermittently. There is reference to the use of wax mixed with potash and size in a fifteenth-century manuscript from Mount Athos, said to record eleventh-century practice; and in a recipe recorded by one Jehan Lèbègue in the fifteenth century as a supplement to a copy by him of another manuscript, wax emulsified with water plays a part. Mixtures which included wax dissolved in turpentine or some similar solvent which evaporates in due course were frequently used in the nineteenth century. Hippolyte Flandrin used such a medium for his wall paintings in St. Germain-des-Prés, Paris, and in other buildings; Gambier-Parry in England also made use of wax in a process called 'spirit fresco'; and similar wax mixtures were on occasion used in Germany and in England. These were not applied to the support direct, but on to a ground, and in essentials were very much the same as oil painting.

In Germany, also, in the nineteenth century, experiments were made in the use of true encaustic, which has developed into a

considerable revival. As used today the wax is mixed with a certain amount of a resin to give it greater strength and flexibility. This is used on a hard support, such as wood. Mixed with oil instead of resin, the medium can be used on canvas. In both cases, a ground is introduced. The colours are mixed with the medium on a heated palette, and applied to the support which may be either cold or heated. The painting is then heated from the front, to fuse the layers of paint and unify the surface. The wax usually employed is, and has been, beeswax, treated to remove impurities and sometimes bleached. Paraffin wax, which differs in composition from beeswax, is even more stable, but in practice does not work so easily.

The great merit of wax used as the main part of a medium is its stability. Freed from impurities it has no effect upon pigments with which it is mixed or on grounds or supports to which it may be applied; it is not affected by the atmosphere; and does not expand or contract with changes in temperature or humidity. It also yields a very pleasant surface quality, glossy, but not too brilliant, which gives softness to the colour, while keeping its brightness. It is not, however, a very tough or hard medium and does not stand up well to hard usage, while in practice it is not easy to handle and involves a considerable amount of apparatus.

Wax emulsified, or dissolved in (say) turpentine, and mixed with other constituents to form a medium, also helps to yield a pleasant mat surface, and has the advantage that it can be used without heat. Such wax paints can now be bought commercially. One drawback is that the colour becomes paler as the paint dries; and it is sometimes very difficult to judge what strength of colour to use. Another is that the other constituents of the medium, such as oils or resins, may in process of hardening contract and crack the wax. It is thought, for example, that the poor state of some of Sir Joshua Reynolds's paintings is due to experiments with wax as part of his medium.

*Pastel*, as compared with wax, is a comparatively modern process. It was known in the seventeenth century, but it was not until the eighteenth century that it came into widespread use, though since then it has remained continuously in favour.

The essential feature of pastel is that the pigment is mixed with a small amount of medium, and moulded into sticks or cakes; and is then applied directly to the support by hand. Usually, the pigment is first mixed with a *filler*, usually pipe-clay or whiting. This improves the covering power of the pigment, i.e. its power to conceal the surface to which it is applied; and by mixing different amounts of pigment with the filler, a wide range of colours can be obtained, which since the filler is white, are many of them the pale soft tints called commercially 'pastel shades'. The binding medium used is usually gum tragacanth, a gum of which only a small part is soluble in water, but which swells to form a sticky mass with which the pigments are mixed. Many other substances may be used, however, such as skimmed milk and soapy water; while Russell, one of the leading English pastel painters, used spirits of wine, evidently relying upon resinous impurities therein to act as a binder.[1]

The pigments used in pastel are only limited by the fact that the medium or binder encloses the particles imperfectly, and is apt itself to be fragile, so that its protective power against external impurities or interaction between pigments is not great. Thus, as Russell points out, white lead, which is very satisfactory when protected by oil, in pastel tends to turn black owing to sulphur in the atmosphere. The use of poisonous pigments (e.g. those containing lead or arsenic) is also to be avoided from the painter's point of view, since he may breathe-in the dust which it is difficult to avoid making when using pastel.

As a material pastel is to be distinguished from the harder chalk crayons, much used by artists for drawing, in which the pigment is mixed with an oil or wax, and moulded into sticks. Confusion is apt to arise, since pastel is sometimes called crayon, especially in the eighteenth century.

The support is generally paper, though canvas is sometimes em-

---

[1] Cf. John Russell, *Elements of Painting with Crayons*, 2nd edit. 1777, p. 42. A little-known, but very authoritative account of eighteenth-century practice. Daniel Gardner, a contemporary of Russell who used pastel, also used 'crayons scraped to dust' mixed with brandy or spirits of wine (see Whitley, *Artists and their Friends in England*, i. 278).

ployed, and occasionally vellum. Russell notes, however, that vellum is liable to mildew in an unfavourable climate, which will change the colours. Generally, paper is pasted on to linen or fine canvas, mounted on a wooden frame or stretcher, or mounted on millboard; canvas is either mounted on a stretcher or on millboard. This mounting is desirable to give firmness. The surface of the support is often treated to give it the necessary tooth to hold the pastel. According to Russell, Maurice Quentin de la Tour, one of the greatest exponents of pastel, used to brush over the paper with gum water, and sprinkle this with smalt, a vitreous blue pigment. This gave him both a suitable tooth and a tinted ground on which to work. Finely ground pumice stone is today a usual material for this purpose.

In using pastel, if a preliminary drawing is necessary, Russell recommends that it be made on another piece of paper, and then transferred to the surface on which the painting is to be made; the reason being that erroneous strokes of the sketching chalk, which contains grease, will prevent the pastel adhering to the surface. The pastel painting can be built up in a succession of touches which are left undisturbed. More usually, however, especially in the eighteenth century, the design is laid in with a few colours, which are then to a certain extent fused by rubbing with the fingers or with a stump. Russell mentions the use of carmine, white, and black for this 'dead colouring'. The final touches are then put on direct and left untouched as may be seen in a detail from a pastel by Mary Cassatt (Pl. VII *b*). Variations in the proportions in which rubbing and direct touches are used can give a wide range of effect; and are found not only from artist to artist, but in the work of the same artist. De la Tour, for example, used rubbing extensively, while his contemporary, Perronneau, gave more prominence to the unfused touch. Russell points out one peculiarity of pastel. Since it is difficult to get very dark pastel colours, owing to the white filler with which the pigment is mixed, the painter must make his picture as rich and dark as possible at the beginning; and if the light tints become predominant, they will continually work up through darker colours.

Applied direct, pastel yields a delicacy and luminosity at least equal

to that obtainable by any other process. The pigments, held very lightly in the medium, can reflect the maximum of light, and on occasion can literally sparkle. Moreover, if the pigments are properly chosen, from the point of view of permanence, the whole painting lasts well, since the filler with which the pigments are mixed is inert, while the medium is not unduly liable to change or decay, and so involve such troubles as cracking. On the other hand, the range from dark to light in pastel, owing to the mixture of white with the colours, is less than in some other processes, notably oil. Also, pastel is not easy to handle so that its full beauty is realized. If rubbed too much, the colour may become dull and lifeless. Moreover, it is difficult to make corrections or to work over the surface without the paint becoming muddy. Another problem for the user of pastel is to ensure that the pigments he uses are reasonably permanent. Pastels supplied commercially are sometimes only chalk stained with dyes of which the colour will soon change or disappear. Consequently, it is often recommended that the artist make his own pastels. Pastel's worst defect, however, is its fragility. It is very loosely held on the support or ground, especially when it is used lightly and directly, in the most effective way to realize its qualities. A painting in pastel must always be kept under glass, to avoid the risk of an incautious touch, and a sudden knock or continuous jarring, such as that due to traffic, will almost certainly shake the paint from the surface.

This fragility has been the cause of many experiments with fixatives for pastels, such as a transparent resin (e.g. shellac) dissolved in a volatile liquid, which is sprayed on the surface. This surrounds the particles of pigment and filler, and helps to bind them together and secure them to the ground, and so becomes part of the medium. But, inevitably, it also tends to saturate the particles, and to make them more transparent, so reducing the brilliancy of the colour. Degas, who used pastel superbly, is reported by Vollard never to have used commercial fixatives, since they gave a shine to the surface, and changed the colours. A fixative was particularly necessary for Degas. He is said to have worked over his pastels a great deal, fixing each layer to secure good adhesion among the different layers; and then to have

completed the work with touches of pure pastel. Probably from these last touches comes the powder colour often found at the bottom of the frame of a Degas pastel.

Pastel is sometimes effectively combined with other processes, to give sparkle and liveliness to the final touches. Degas, again, sometimes used it in combination with much thinned oil paint, which dried with a mat surface. More often, it has been used in combination with water-colour, which in most of its uses does not affect the tooth of the surface to which it is applied.

Another attempt to combine the advantages of pastel and to avoid its defects was that of J. F. Raffaelli, the Impressionist painter. He had pigments made up into sticks with a softer wax than that used for crayons, as being stronger than the binder of ordinary pastel. These sticks could then be used like pastel, giving a similar effect. But the result could be varnished, to give a shiny surface; or some wax solvent such as turpentine could be lightly applied, slightly to fuse the colours; or again, the colours could be applied to a painting begun in oil, and the whole varnished. In fact, the process never attained any popularity, but references to it are sometimes made, and it is therefore mentioned here.

*Water-colour*. Indubitably, this is the most widely used process in which the only essentials are a paint layer and a support. The pigment is mixed with a medium soluble in water, which is used as a diluent, and evaporates after the paint layer is applied to the support. It is important to realize this, as water is often spoken of as the medium in water-colour painting, while in fact it plays the part of turpentine and other volatile substances in oil painting, and is simply a means of varying the consistency of the paint, either to make it more tractable to handle or to vary the thickness of the paint layer.

As well as being one of the most widely used processes, water-colour is one of the oldest, having been used in classical times. In water-colour also have been executed some of the greatest masterpieces of painting. The idea of a painting as something made to hang on a wall, or as decoration applied to a wall, leaves out of account that from the seventh to the fifteenth century in Europe, the

illustration and decoration of manuscripts were among the painter's principal activities, and were carried out entirely in water-colour. Indeed, in northern Europe, it was the painter's chief means of expression, since Gothic architecture gave him less wall space on which to paint than did contemporary buildings in Italy. It may be noted, too, that in the Far East, water-colour has been practically the only process used by the painter and is the one in which the greatest triumphs of Chinese and Japanese painters have been achieved. With the invention of printing in the West, and a consequent change in the whole character of the book, and with the development of oil painting, the use of water-colour became more occasional, generally for such subsidiary purposes as making sketches or tinting a drawing. It remained, however, the principal medium for the painter of miniatures, which had such a remarkable development, especially in England, during the sixteenth, seventeenth, and eighteenth centuries. Then in the eighteenth century came a revival in its use on a larger scale, until in later eighteenth-century England came a remarkable burst of activity and achievement, culminating in the work of J. M. W. Turner and J. S. Cotman in the early nineteenth century; since when, water-colour has again occupied a leading place in a painter's equipment.

This brief incursion into history has been made to emphasize the fact that water-colour is not, as is sometimes imagined, a plaything for amateurs or a means of keeping children occupied, but a process of the greatest interest and importance. In the West, since the Middle Ages, the medium with which pigments are mixed is generally gum arabic, derived from the acacia. The gum is inclined to be brittle, and to make it more elastic, a little honey, sugar, or glycerine, is added. In the Middle Ages, however, the standard medium for manuscript illumination was *glair*. This is white of egg, consisting largely of albumen, which by various methods has been deprived of its stringy quality and made easy to mix with water. This can be done either by whipping the white of egg and letting it settle or by squeezing it through a sponge or cloth. In both cases a watery liquid is produced, which can if desired be diluted with water. Gums,

however, were also used in the Middle Ages for the illumination of manuscripts, and apparently for other kinds of painting. A twelfth-century treatise on the practice of the arts by one Theophilus, after pointing out the inconvenience of the slow drying of pigments mixed with oil applied to woodwork, says:

If, however, you wish to hasten your work, take gum which exudes from the cherry or plum tree, and, cutting it up very small, place it in an earthenware pot and pour water upon it abundantly, and place it in the sun, or in winter upon the coals, until the gum has liquified; and mix it together with a smooth piece of wood. Then strain it through a cloth; and grind the colours with it and lay them on.[1]

With the substitution of gum arabic for the cherry or plum gum, this pretty well describes the practice of a water-colour painter up to the days when water-colours could be bought ready mixed in tubes.

Supports used in water-colour painting vary considerably. Whether wood, as described by Theophilus, was much used in the Middle Ages, is unknown. But it is conceivable that some of the thirteenth- and fourteenth-century panel paintings, which survive in northern Europe, may have been in water-colour, to which varnish was later applied. But the usual support was certainly parchment, made from the skin of an animal, which was soaked in water and lime to aid in removing the hair and fat, then stretched on a frame to dry, and scraped smooth. Parchment making was a regular industry, and the artist did not normally have to prepare his own. Goat, calf, and sheep skins were the ones most widely used. As D. V. Thompson remarks: 'Probably any city's preferences in the matter of meat diet were reflected in the local parchment industry.'[2] The term vellum should strictly be confined to parchment made from calfskin, being derived ultimately from *vitulus*, a calf; and this was mostly used when big skins were needed, as in the large medieval choir books.[3] Sometimes

---

[1] The translation is that of Laurie, *The Materials of the Painter's Craft*, 1910, p. 165.

[2] *Materials of Mediaeval Painting*, London, 1936, p. 28.

[3] As Thompson (loc. cit.) points out, in modern usage vellum has come, for no reason at all, to be used for smaller and thinner skins which are the least likely to be calf.

in medieval manuals the term *abortivum* is used of parchment, and Edward Norgate in his *Miniatura* (1609–50) speaks of abortive parchment. This has given rise to the idea that the finest medieval parchment, such as that used in the small bibles of the thirteenth century, was made from the skins of stillborn calves, and the name 'uterine vellum' has been coined for it.

Since the Middle Ages the principal support for water-colour in the West has been paper. In the Far East finely woven textiles, especially silk, have been extensively employed, but in Europe their use has been occasional and spasmodic. A famous example is the so-called *Parement de Narbonne*, an altar frontal made in the fourteenth century for Charles V of France which is in monochrome water-colour on silk. The most consistent use of textile supports, however, was in the fan paintings of the eighteenth and nineteenth centuries. The painters of miniatures have pursued an independent course, however. In the sixteenth and early seventeenth century they followed the illuminators in using parchment, though card was also used, sometimes in the form of a piece of a playing card, which had the smooth surface needed for delicate work. Later a thin sheet of ivory became a favourite support, though card has been consistently used and occasionally porcelain.

In water-colour painting the actual support is often mounted on some other material, either before or after working; and this has sometimes caused confusion and misdescription. For example, paper may be mounted on card or linen, and the parchment of the miniaturist was generally mounted on card before working. But such mounting does not affect the nature of the support, and is merely used to give added strength. Again, the support has sometimes to be treated to make it fit to receive the paint. Paper and textiles, for example, should have size (a refined form of glue) incorporated into their texture, to prevent the paint being soaked up and spreading unevenly, as it would be on blotting paper. Any suspicion of grease in or on the support will prevent the paint adhering to the support. This is apt to be the case with parchment, or with paper and ivory when they have been touched by the fingers, and it may be necessary to

wipe the surface with some liquid like benzine or ox gall, to remove any traces of grease.

The degree of absorbency of the support has a considerable effect on the appearance of a painting. A thick, heavy, absorbent paper, for example, will yield a richer, softer result than a thin, close-textured, smooth-surfaced one, but will not allow the same delicacy and precision of detail. Also, the more absorbent the support, the more thoroughly the medium can penetrate it and bind the paint layer and support together. Since parchment and ivory are only slightly absorbent, they are particularly suitable for work involving delicate detail; but any bending of the support is liable to break and detach some of the colour layer. So it is that the pages of an illuminated manuscript should be turned so that they lie as flat as possible.

Water-colour painting falls into two main types, transparent and opaque, the two sometimes being combined in one painting. In water-colour used so that it is transparent, light is reflected not only from the particles of colour held in the medium, but penetrates the paint layer and is reflected back through it from the support, so increasing luminosity. In character, though not in intensity, the effect of the transmitted light is comparable to that from a stained glass window. Transparent water-colour also allows any preparatory drawing with chalk, pencil, pen, or brush to remain visible to an extent depending on the density of the paint layer. In many manuscript illuminations of the earlier Middle Ages, in many eighteenth-century water-colours, and frequently in architectural water-colours of today, the paint is used merely to tint a drawing; hence the use of the term 'water-colour drawing', which still continues as distinct from water-colour painting. In such use of water-colour, however, the drawing is not necessarily finished before the paint is applied. Usually the design is lightly sketched in, the colour put on, and the drawing then completed. This not only enables the drawing to tell better, but permits it to be made with inks or with water-colour itself, which might otherwise be washed out or blurred by the water-colour.

During the later eighteenth and especially the nineteenth centuries,

however, the use of transparent water-colour became much more complicated. Following the example of painters in oil, who built up their work in a series of layers of paint, the water-colour painters proceeded to do likewise. The earlier layers were usually in monochrome; and for this 'lay-in', as it is sometimes called, india ink or indigo mixed with other colours to yield a grey was often employed. First, the main forms would be indicated by means of a flat wash,[1] the lights being very carefully reserved; varying degrees of darkness in the forms would then be indicated by adding washes where necessary, and shadows would be added or intensified by the same means. The painting would then be finished in different ways. Sometimes, this would be by further washes in grey and definition of detail by touches of varying sharpness and depth of tone; sometimes, warm grey or brown tints might be added in the foreground (see Pl. VIII, a washed drawing by Canaletto). Increasingly, however, colours came to be added, in the form of flat tints over the appropriate parts of the monochrome foundation, detail being added by touches of colour. The whole process is well exemplified in an illustration (Pl. IX) taken from a book by Francis Nicholson, a well-known water-colour painter of the early nineteenth century, highly skilled in the traditional handling of water-colour.[2] The importance of reserving the lights in a water-colour painting is emphasized by the occasional practice of covering them with a waterproof composition to be removed when the painting was finished. Sometimes, however, lights were painted over by accident or had to be introduced in unforeseen places. Then the area of the required light was wetted and the colour wiped away; or where a sharp light was wanted, it might be taken out by scraping down the paper with a sharp penknife.

There were, of course, all kinds of individual variations in the process as described above. With such variations, it found, perhaps, its

---

[1] *Wash* is the technical term used when the paint is sufficiently diluted with water to flow easily, and is carried over a considerable area with broad sweeps of the brush, leaving no indication of brush marks.

[2] *The Practice of Drawing and Painting Landscape from Nature in Water Colours*, London, 1820.

greatest early exponent in J. R. Cozens, whom John Constable, with pardonable exaggeration, called 'the greatest genius who ever touched landscape'; and it continued to be used until well on into the nineteenth century. The advantage of this orderly and systematic approach to water-colour, which can be reduced almost to a formula, is that subdivision of process makes it easier to avoid irremediable mistakes, and limits their effect on the final result; while the underlying monochrome lay-in helps to keep unity. Moreover, it is one of the major difficulties of water-colour, that attempts to modify the depth or colour of a wash once applied are apt to result in muddiness; while a series of thin washes building up towards the depth and colour required, help to preserve transparency. But the process has its drawbacks. The range and vividness of colour is limited by the pervasive monochrome foundation; and a single wash, applied at full strength, is likely not only to be more transparent than a series one on top of another, and so give greater luminosity, but by leaving here and there tiny areas of the support uncovered, to produce more sparkle.

So it came about that even among Cozens's immediate successors the monochrome foundation often came to be given up, and an increasingly direct use of colour substituted. Superimposition of one wash upon another continued, e.g. in the case of shadows, or where the colour of an object was not uniform; and detail was introduced after the main washes had been applied. At the same time, the importance of the underlying drawing diminished, broad general indications replacing the precise detail of earlier days, and the tinted drawing of earlier days largely disappeared. In these developments, water-colour was following the same path as oil painting, where (as will be seen later) what is called direct painting was coming increasingly into favour. Older methods died hard, however, and persisted alongside others until almost the middle of the century, especially in the case of water-colours that were to be used for reproduction by colour lithography. Even today there are water-colour painters who put in shadows in monochrome under or over washes of local colour.

The new freedom in the use of transparent water-colour took several forms. In the earlier work of J. S. Cotman, it consisted in

an elaboration of the tinted drawing, the design being constructed in subtly harmonized cloisons of luminous colour, for the most part washed in directly at full strength (Pl. X). J. M. W. Turner, in his later work, often used most elaborate combinations of washes, direct or superimposed, reinforced by direct touches or by hatching and stippling;[1] while in the more elaborate works of such painters as Copley Fielding and Birket Foster, hatching and stippling became the mainstay. Constantly, the water-colour painter tried to rival the range in colour and tone of oil painting, its elasticity, and its richness; and the attempt still goes on, resulting in productions which do not in fact achieve the special characteristics of oil, and lose the delicacy and luminosity of water-colour. This can only be attained to the full by putting down each wash or touch swiftly, and leaving it to dry untouched. A few modern painters can achieve technical miracles by steering with brush, rag, and sponge, pools of liquid paint across sheets of paper, washing out here, adding colour there, and so on; but with them as sometimes even with Turner, who knew every trick and device of manipulation, the results too often lose freshness and sparkle. Fully to realize the beauty of transparent water-colour, the painter has to know from the beginning exactly what he wants to do, exactly how he is going to do it, and to do it directly and without fumbling; and then, as a great water-colour painter once said, he is lucky to get what he wants once out of five tries. It is all the more surprising, therefore, that water-colour is the traditional material for the instruction of beginners. A probable explanation is that it is clean about the house.

The use of water-colour in miniature painting differs somewhat from that described above. Incidentally, the term miniature has in origin nothing to do with the size of a painting, but derives from the Latin word *minium*, used in the Middle Ages for orange lead or vermilion, pigments much used in early manuscript illumination. As a description of small paintings similar in size to those in manuscripts, and

---

[1] *Hatching* is the term used for covering an area by means of a series of small touches of colour instead of a wash; *stippling* implies yet smaller touches, made with the point of the brush.

on similar materials, its first use seems to be in the early eighteenth century. Previous to that, such paintings were generally called 'limnings', and the process of painting them 'limning', a word derived from the Latin word *illuminare* (= to paint) which again establishes a connexion with the illuminated manuscript.

In course of time the technique of miniature painting changed somewhat. Early practice is described in two famous treatises, one written about 1600 by Nicholas Hilliard,[1] the greatest of early miniature painters, the other entitled, *Miniatura or the Art of Limning*, by Edward Norgate, written between December 1648 and October 1650.[2] The portrait (and miniature painting is almost entirely a portrait art) is first what Norgate calls, 'dead coloured', by which he means outlined with the brush with shadows indicated, a stage corresponding to the lay-in of the earlier water-colour painters. In a second stage more detail is introduced, and the resemblance to the sitter strengthened; and in a third the shadows are deepened, smaller shadows introduced, detail added, and lights applied. Norgate emphasizes that in the beginning the painter should work 'gently and faintly, because it is observable that in all Colours of Lymning, you can adde as often as you please but be sure never to lay them too deepe; which if you doe, it wilbe hardly helpt without spoiling, or defacing your peece, because as I said before, there is noe heightning of a face in Lymning, the white touches for the light of the eyes and hair excepted'. Hilliard is equally emphatic, remarking that 'the botching or mending wilbe perceiued when one hath taken away any caler one the face, for the carnation will never be of the same cullor again'. Hilliard, too, describes the method of painting, saying, for example, that 'shadowing in lymning must not be driven with the flat of the pensel [brush] as in oyle work, distemper or washing, but with the pointe of the pencell by little light touches with cullor very thine, and like hatches as we call it with the pen'. Here is the hatching and stippling of the nineteenth century. But the method described

[1] Published Norman, *Walpole Society Annual I*, 1912; see also John Pope-Hennessy, *Journal of the Warburg Institute*, vol. vi, 1943.
[2] Ed. Martin Hardie, Oxford, 1919.

by Hilliard and Norgate differs from that used in transparent water-colour in that white is not only used for the 'white touches', but is mixed on occasion with other colours. In Norgate's words, 'white is ever a dayly guest, and seldom absent but in the shadowes'. That reliance was also placed upon the paint being transparent so that light could be reflected through it from the ground, appears from Norgate's strong advocacy of laying a ground upon the parchment support which suited the complexion of the sitter; contrasting the English way of 'painting upon solid and substanciall body of colour' favourably with the 'slight and washing way' of the Italians, who 'worke the Complexion upon the bare parchment without more adoe'.

It was, however, the 'slight and washing way' which eventually triumphed in Western miniature painting. The majority of English and French miniatures of the eighteenth and early nineteenth centuries are painted on ivory in transparent water-colour, either in small touches or by stippling, the main lights being supplied by the support, but with touches of white in the high lights.

*Opaque water-colour*, generally known as gouache, sometimes as *body colour*, differs from transparent water-colour only in the pigments being mixed with white. Until the middle of the nineteenth century, the white was generally white lead, a mixture of lead carbonate and lead hydrate, though bone ash or chalk were sometimes employed; after that date, zinc white (zinc oxide, often called Chinese white) has been almost invariably used. The opacity of gouache varies with the amount of white mixed with the other pigments, but is generally enough to prevent reflection from the ground through the paint. It therefore lacks the luminosity and sparkle of transparent water-colour, though it has a delicate atmospheric quality, akin to that of pastel. Its comparative opacity can generally conceal anything beneath it, and so allows additions and changes to be more easily made than in transparent water-colour. Gouache was much used in the illumination of manuscripts, especially in the later Middle Ages, when illustration as distinct from decoration became more important and elaborate. Some form of gouache or size colour (see below) was

also employed for painting the earlier book covers in the famous series in the archives at Siena, used to enclose Treasury documents. As regards the method of its use, the Tickhill Psalter, written and decorated in England in the early fourteenth century, contains a number of unfinished pages, which enable the process of manuscript illumination to be followed.[1] According to an early inscription, the manuscript was written, and the gold which freely decorates the pages applied, by John Tickhill, formerly prior of the Monastery of Worksop. The rest of the decoration is evidently by various hands, and is an example of the collaboration characteristic of a medieval workshop. Dr. Egbert describes the work on the illustrations and decorations as follows:

The figures and details were first rapidly indicated with very pale brown ink, then carefully, though impressionistically, drawn with black ink by a draughtsman of extraordinary ability. . . . Next, gold leaf was applied over gesso and highly burnished, except that it was neither applied over gesso nor given a high polish when used, as it sometimes was, for the clothing of important human figures. After the heavy body colors had been applied to the garments, etc., final touches were then added in the form of highlights in white, the lines of the drapery folds were picked out with lines of black and white, and the silhouettes of dark-colored areas were refined and strengthened with heavy and continuous outlines in black ink.

In essentials this description would fit much later practice in water-colour save for the use of gold. This played a most important part, not only in manuscript illumination, but in medieval panel and wall painting; and something is said concerning it in the chapter on tempera painting. To illustrate the above description, an unfinished page from the Tickhill Psalter is reproduced (Pl. XI), and to emphasize it, two pages from the Metz Pontifical (early fourteenth century) are also given (Pl. XII) one with the drawing in outline, the other with the completed painting. It should be noted that the manuscript was written before it was decorated.

[1] The following account is based upon the monograph by Egbert, *The Tickhill Psalter and Related Manuscripts*, 1940.

Gouache was also used to some extent, as already explained, by the earlier miniature painters, and was very popular with the Italian, French, and Swiss water-colour painters of the eighteenth century, and had a particular vogue in Rome in the later eighteenth century. Occasionally, it was used in fan painting; but transparent water-colour is more usual, as the film of paint in the case of gouache is thicker, and lies more on the surface of the support, and is therefore more liable to crack with folding or unfolding of the fan.

Sometimes gouache and transparent water-colour are found together in the same painting, an example already mentioned being the work of the earlier miniature painters. Later, gouache was mainly used to pick out and emphasize high lights, as in later miniatures, and in many transparent water-colours in the nineteenth century, such as those of F. L. Lewis and his contemporaries.

A third type of water-colour painting differs from the others in that instead of glair or gum, the medium is size, the term used in painting for gelatine or much purified glue, prepared from the skin and bones of animals. Well known is parchment size, made by steeping pieces of parchment in water.[1] Size is the medium normally used in Far Eastern painting. In the West, in northern Europe, it seems to have been used in wall painting, and in panel painting, not as a medium by itself, but as part of more complicated processes. In panels, for example, it was combined with the use of oil, and is more properly considered under oil painting. Occasionally, however, pigment mixed with nothing but size seems to have been used in the Middle Ages. The famous Chichester Roundel, a painting of the Virgin and Child in Chichester Cathedral, is said to be painted in size on two slats of stone let into the wall. Further investigation may produce other examples. When used as an independent medium in the West the pigments are usually mixed with white to form opaque paint, called size colour, distemper, or, loosely, tempera. This last

---

[1] Some authorities (e.g. Church, *Chemistry of Paints and Painting*) distinguish size from glue, on the ground that in preparing glue, parts of the animal other than skin and bone are used, so making the composition of the glue different from that of size. Again, the term 'size' is sometimes loosely applied to anything used to stiffen paper and fabric.

term, however, is best reserved for paint in which the medium is yolk of egg (with or without the white) described in detail later; a distinction being that size colour unmixed with anything else remains soluble in water, and is therefore strictly related to other forms of water-colour, while egg tempera hardens to an insoluble substance.

Frequently, however, oil, casein, or other substances are mixed with size colour,[1] so that when dry it forms a film insoluble in water, which for practical purposes brings size colour nearer to true tempera. Paint of this type seems to have been used on canvas in the Middle Ages and the sixteenth and seventeenth centuries, for banners and decorations at religious and other festivals; and mixed with white to make it opaque, this kind of size colour is much used for painting theatre scenery, and is the basis of the commercial washable distempers. It is also the basis of the so-called 'poster colours' extensively used not only for poster design, but in all forms of commercial designing. Its advantages for this type of work and for scenery painting are that it covers large areas easily, can be used on cheap paper or canvas which at most needs only a coat of size to be ready for use, and that owing to the opacity of the paint, alterations and corrections are easy.

In all its forms, water-colour has two main disadvantages. Paper, the support chiefly in use since the Renaissance, is particularly liable not only to damage by being torn or crumpled, but to various forms of disintegration. One that is especially dangerous is due to damp. Not only is the paper itself and the size with which it is treated hygroscopic, but the size is a favourable breeding ground for various kinds of vegetable growths, which result in yellow and brown areas of discolouration, known as 'foxing'.

The second disadvantage is inherent in the medium itself. Gum, glair, and size are not at all efficient in so locking up the pigment as to protect it from the combined effects of light and atmosphere. Gum and size, in fact, are inclined to attract moisture. This means that the range of pigments which can be safely used in water-colour is re-

[1] In the case of oil substances, this mixing is known as emulsifying (v. Chap. 7).

stricted. White lead, which in oil is usually stable, in water-colour is very liable to blacken by absorbing sulphur from the air, and turning into lead sulphide.[1] Indigo, much favoured by the earlier water-colour painters, oxidizes and turns brown when exposed to air and light; Prussian blue, also once in great favour, changes colour; chrome yellow turns greenish and darkens; and the pigments derived from cochineal, such as carmine, rapidly turn brown. That the colours in most illuminated manuscripts are so well preserved is due to their being only occasionally exposed to light and air, though if, as sometimes happens, a manuscript has remained open for considerable periods at a particular page, deterioration can often be detected.

The restriction on the range of pigments safe to use need not hamper the painter in water-colour, since there is left an ample number of alternatives. It emphasizes, however, the necessity of knowing this aspect of his craft, if the work is to endure. These basic weaknesses in water-colour have, however, inspired various attempts to protect water-colours by the use of a varnish. Nicholson, in his *Practice*, gives a recipe for one of these. In fact, such methods are unsatisfactory. The varnish penetrates the paint layer, and locks up the pigments more or less securely; but by changing the reflecting power of the pigment particles it alters and darkens the colours, and robs the drawing of luminosity and sparkle. Moreover, the varnish soaks into the paint layer and support; and if (as is likely) it darkens or disintegrates, it is almost impossible to remove.

Consequently, the best way of preserving water-colours is more or less to reproduce the conditions established in an illuminated manuscript, by mounting them and keeping them in a box. The mount itself should be of pure rag card, free from any substances such as sulphur; the painting should be lightly attached to the mount with a paste free from possibly harmful ingredients; and the depth of the opening in the mount should be sufficient to prevent the surface of the painting being rubbed. A sheet of cellophane between the painting

[1] This can often be remedied by exposure to strong light, or to hydrogen peroxide vapour, though such treatment may be harmful to other pigments.

and the front of the mount is a useful aid in this. If framed and hung on walls, water-colours should be under glass and hung in a place where the humidity is fairly low, and not exposed to strong light. When not hanging, they should be removed from the frame and stored.

# 5

## PAINTING PROCESSES: FRESCO

FROM processes in which the painting is normally composed of two layers, paint and support, turn to those in which there are three layers, due to the use of a ground laid on the support. By far the most important and numerous of these are employed in mural painting, though, as noted above, examples occur when a ground is introduced in water-colour painting, or, as will be seen later, when one layer is omitted in what is ordinarily a four-layer process. It is true that there are examples in north European medieval work of paint being applied direct to a wall, a notable case being the paintings in Eton College Chapel. Ordinarily, however, the surface of a wall is too rough, and its texture unsuitable, to receive the paint; and almost invariably a coat of plaster is laid on the wall as a ground. It should be noted, however, that certainly in early practice, this coat of plaster was considered preparation of the wall to receive the paint, and not as a means of concealing major undulations and inequalities in the wall, and so producing an absolutely flat surface. Indeed, skilful use might be made of major undulations in the wall surface, on which the light would fall at slightly differing angles, to produce variations in colour and especially in the appearance of gilding. An example is the famous *Adoration of the Magi* by Benozzo Gozzoli in the Medici Palace, Florence.

Once the plaster is on the wall, a wide range of mediums is open to the painter. He may use a wax medium, oil in various mixtures, size, casein, or half a dozen other materials; but up to the end of the seventeenth century and especially in Italy, if he wanted to complete his work merely by adding a paint layer, he would almost invariably use some form of *fresco*.

*Fresco painting* is of two types, *fresco secco* (dry fresco) and *buon fresco* (good fresco).[1]

The plaster used in both cases is lime plaster, made with slaked lime (calcium hydrate) and sand mixed with water. Lime by itself is liable to shrink and crack, hence the presence of the sand, round the particles of which the lime crystallizes. The setting of lime plaster has two stages; and to understand these is also to understand the basic character of fresco. In the first the bulk of the water in the plaster dries out; in the second carbon dioxide from the atmosphere acts upon the calcium hydrate to produce calcium carbonate, which is practically chalk or limestone, and leads to a further evaporation of water. This process of forming calcium carbonate is very slow, and is helped by periodically wetting the plaster.

In *fresco secco*, the surface of the plaster was allowed to dry. The pigments were mixed with slaked lime and water, the surface of the wall plaster damped, and work proceeded. The damping of the plaster allowed some penetration by the paint layer, and made it fast to the plaster; the lime mixed with the pigment was converted into chalk, and held the pigments enclosed. As a process, this is akin to water-colour. The pigments are mixed with a medium, with water as a diluent, and applied to the ground. From the number of surviving examples it is clear that this was the prevailing method of wall painting in the Middle Ages in northern Europe and in Spain. The exact procedure is, however, unknown, though its essentials are given by Theophilus in the twelfth-century manuscript already mentioned, when he says, 'When figures or birds or representations of other objects, are drawn on a dry wall, the wall must be immediately sprinkled with water until it is quite wet. And all the colours which are to be put on, must be mixed with lime, and laid on at one wetting, in order that they may dry along with the wall, and may adhere to it.'[2]

---

[1] In early authorities, the term *fresco secco* does not seem to be used, and the term *secco* alone is used for any process of painting on a wall when it is dry. But the terms as used today are convenient, as they suggest the similarities and the differences of the two types.

[2] The translation from the Latin is from Mrs. Merrifield, *The Art of Fresco Painting*, 1846, p. 18.

Concerning the process of *buon fresco*, unlike that of *fresco secco*, a great deal of information has come down to us, since a long succession of Italian painters have described it in detail. The use of *buon fresco* is indeed almost limited to Italy; and in that process some of the greatest masterpieces of the world from the fourteenth century onwards were executed. In the nineteenth century a determined effort was made to bring *buon fresco* into use in northern Europe. At the time of the so-called Gothic revival and of the newly aroused enthusiasm for early Italian painting, there was much research into methods and materials, and a number of reasonably successful applications of its results made. Such were the paintings by William Dyce in the Houses of Parliament in London, and of Peter von Cornelius in the Glyptothek at Munich, and elsewhere. But the tradition of using the process had been lost. It is one thing to learn a method from books, another in a workshop; and in practice, *buon fresco* proved difficult to handle and uncertain in results, so that even such great painters as Delacroix and Puvis de Chavannes in their mural work adopted the method of painting in oil (or some adaptation thereof) sometimes direct on the wall, but often on canvas which was later attached to the wall, a process sometimes known as *marouflaging*.

To return to *buon fresco*. The essential element of this is that the painting is done while the plaster is still wet. The pigments are mixed with water only, and on being applied are carried with the water into the plaster and locked up in it as it hardens into carbonate of lime. In the great days of fresco much attention was paid to the plastering of the wall. At least two coats were applied. The business of the first was to adhere firmly to the wall, and its surface was roughened so that the second coat, on which the painting was to be carried out, should also hold fast. This is the system recommended by Cennino Cennini, in his *Libro dell' Arte*, one of the most famous handbooks of the Middle Ages on painting and related arts. It was written some time between 1396 and 1437. Cennini was a pupil of Agnolo Gaddi, son of Taddeo Gaddi, the pupil of Giotto, and he takes pride in recording the workshop tradition based on the practice of that

great master, which it is tolerably certain ruled for many years in Italy.[1]

When the first coat of plaster is dry, Cennini tells the painter to draw his design thereon in charcoal, this design apparently being based on a small drawing. It is interesting to note that various mechanical aids, such as plumb-lines and compasses, are recommended as a means of placing figures, &c. The charcoal is then to be gone over with ochre and red, with a small brush, some shading being introduced. Then comes the stage which has puzzled some later students. Over the design, another coat of plaster often called the *intonaco*, is to be applied, this being fairly thin, and to be made quite smooth; and to this, the pigments mixed only with water are to be applied. Evidently, the second coat of plaster, while wet, was sufficiently thin for the underlying design to be seen. Any doubts as to Cennini's method being as described, were dispelled as a result of the damage done in the Campo Santo at Pisa during the Second World War. There, as the results of explosions and subsequent rain, the final coat of plaster on certain frescoes, which carried the painting, was removed, to reveal the drawing on the underlying coat, and some of the lines used to place the figure (Pl. XIII).

The importance of the plaster on which the painting is made being wet is emphasized by Cennini's instruction to 'consider in your own mind how much work you can do in a day; for whatever you plaster you ought to finish up'. Cennini does not mention it, but it was the practice to undercut the edges of the section of plaster used for each bout of painting, so that the succeeding sections, when they came to be applied, could be neatly and firmly fitted to the previous ones. The joints, however, are always clearly visible in *buon fresco*, and afford one of the easiest means of distinguishing it from *fresco secco*, in which the jointing was unnecessary. The major difference between the two types, however, lies in their degree of permanence, and sometimes in quality of colour. In *fresco secco*, the pigments are held only in a thin film of chalk, which when applied in the form of

[1] An excellent translation of Cennini, with notes and explanations, is that by Daniel V. Thompson, Jr., 1933.

lime water, never penetrates far into the plaster of the wall, and is therefore liable to scale and flake; while in *buon fresco*, the waterborne pigment goes deeper into the wet layer of plaster, which can be more firmly bound to the underlying layer. Also, in *fresco secco*, any excess of lime water is liable to cloud and muddy the colours, while in *buon fresco* they remain clear.

In both *fresco secco* and *buon fresco*, it was usual to complete and touch up the work *in secco*, that is, after the painting was dry. A medium sometimes used was size; but Cennini recommends two forms of egg tempera (for this, see the chapter on Tempera). This not only enabled detail and subtleties to be introduced unattainable in fresco, but since the size or egg allowed pigments to be used which could not be used in fresco (as explained below), richer and more varied colour was possible. Sometimes, too, gold would be applied to certain parts of the fresco, as in the haloes and the capitals of the columns in the fresco by Melozzo da Forli (fifteenth century) now in the Vatican. In time, however, some of these additions have changed colour or darkened more than the fresco itself.

In the course of the fifteenth century and especially during the sixteenth century, refinements and elaborations of Cennini's methods were introduced. This appears from various sixteenth-century descriptions of the process, notably that of Giorgio Vasari in the introduction to his *Lives of the Painters*, by which he is better remembered than by his work as painter and architect. A minor development was the greater care taken over plastering the wall, one great authority recommending at least three layers, with special attention given to the final coat of *intonaco* on which the painting was to be made. Much more important was a change in standard methods of transferring the design to the wall. The older plan still persisted of dividing the wall into geometrical areas, and copying from smaller sketches divided up in the same way, so that the copy could be made section by section; but the usual and recommended way was to prepare from the sketches *cartoons*, consisting of large sheets of paper on which the design or portions of it were drawn of the same size as they were to be on the wall. These, too, were made by squaring up

(as it is called) and copying the smaller drawing square by square. The design was then transferred to the *intonaco* or final layer of plaster in one of two ways. Either the cartoon was placed on the newly laid *intonaco* and the lines traced with a metal point, which since the plaster was soft, made an indented line; or the design was *pounced* on to the *intonaco* by pricking the lines of the cartoon with a needle, placing the cartoon on the wall, and shaking some finely divided dark substance, such as ground-up charcoal, through the holes. The pounced outlines would then be gone over with a brush and colour. Plate XIV shows the first and last stages of this process in the case of a fresco by Correggio—the preliminary drawing squared up for enlargement on to the cartoon, and the finished fresco. That a cartoon was made is evident from the incised lines on the fresco, which indicate how the design was transferred to the plaster. But the cartoon has disappeared and was probably destroyed, as was often the case, since they were fragile, liable to be damaged in the course of work, and bulky to store.

It is to be noted that if sixteenth-century artists did not, as Cennini recommends, make the design on dry plaster, and cover it with *intonaco*, but on the *intonaco* direct. By devices such as these, by attention to the fineness of the *intonaco*, and by skilful handling of the paint, the painters of the time believed that additions *in secco* were unnecessary. In the words of Vasari, 'therefore let all those who wish to paint upon walls, paint in fresco, like men, without retouching in *secco*; which besides being a most vile practice, shortens the duration of the pictures'.

In well-trained hands fresco can yield results of great breadth and simplicity, combined with luminosity. The very nature of the process calls for quick and decisive handling, and forbids labour over details; while the crystalline character of the medium and its mat surface, help to give an airy lightness to the colours. Moreover, if the painter observes certain rules, these results are reasonably enduring. These rules, however, set very definite limits to when fresco can be used, and the effects it will yield. First is the difficulty of getting wall, plaster, and colour into a cohesive whole. Defects in plastering may

easily lead to scaling and flaking. It is particularly hard in *buon fresco* to judge the right consistency (or degree of wetness) of the *intonaco* on which the painting is made. If this is too dry it is liable not to adhere firmly to the underlying plaster, and the pigment will not penetrate. If it is too wet, however, the brush used for the colour will disturb the plaster, and the colour itself may run. An example of these difficulties are the above-mentioned nineteenth-century frescoes painted by Dyce in the Houses of Parliament. The first of the series began to flake and peel soon after it was finished; and as there was no workshop tradition to guide them, the artist and his plasterers had to learn as they went on, and full mastery was only achieved towards the end. The later frescoes, however, are good examples of how resistant fresco can be to what might ruin other forms of painting. The windows of the room they decorate open on the river Thames, and oscillations of temperature and humidity are considerable, while from across the river, smoke-laden air from factories enters. The frescoes became filthy; but when cleaned, the ones painted when the process was fully understood were found to be in fairly good condition. Nevertheless, exposure to air containing sulphur is likely to be harmful by converting the carbonate of lime of the fresco into sulphate, with disintegration as the result. The major enemy of fresco, however, is damp, less on the surface of the painting than from behind. This not only disintegrates the plaster, but carries salts to the surface of the painting where they crystallize and form blotches, while providing favourable conditions for the formation of mould. So, stringent precautions are needed against damp from outside the wall, and, above all, from below the wall. This is perhaps the chief reason why *fresco secco* fell into disuse in northern Europe, and why *buon fresco* was never extensively used. But if damp can be guarded against, and extensive pollution of the air, fresco could as well be used in northern climates as elsewhere.

A third difficulty in the use of fresco comes from the restricted number of pigments that can safely be used. The lime carbonate is not completely effectual in protecting the pigments from the influence of light and atmosphere, and, as in water-colour, pigments

such as white lead, verdigris, and some of those derived from vegetable sources, cannot be used. In the great period of fresco painting the white used was lime putty (made by keeping lime with water for a long time) and later lime carbonate (chalk) made by exposing lime putty to the air. An additional limitation is that the alkali in lime changes the colour of some pigments, those which are organic being particularly liable to change. The painters of the fifteenth and sixteenth centuries held that only natural as distinct from manufactured or artificial pigments should be used. One of them, G. B. Armenini, in his *De Veri Precetti della Pittura*, 1587, says, 'artificial pigments never do well in fresco, nor can any art make them last long without changing'; and adds later 'you may leave to foolish painters those secrets of theirs, which no one envies them, of using vermilions and fine lakes; because, . . . in the long run, their pictures become ugly daubs'. The distinction between natural and artificial in relation to fresco no longer holds good, since there are some comparatively modern manufactured pigments (among them cobalt and green oxide of chromium) which can safely be used; but there still remain many colours on the oil painter's palette which the fresco painter should not use.

Lastly, the dark, rich, intense quality of colour possible in oil, cannot be secured in fresco. It was to widen the range of colours from dark to light, and the number of tints available, that finishing *in secco* with tempera took place. But even so, the strong contrasts and vivid colour juxtapositions of the oil painter were not available. Nor was another means of emphasis and variation, that of loading the pigment in certain places to form what is called an *impasto*. Sometimes, certain parts of a fresco, such as the haloes of saints, or the jewels on a robe, may be in relief; but this is achieved by building up the relief in plaster or similar material, and not by the thickness of the paint. Thus the fresco painter, like the water-colour painter, works with more restricted technical means than the painter in oil.

Just as in the case of water-colour, no safe or effective means of putting a protective layer over the surface of fresco has been found.

Recently, wax has been used for the purpose; but it is apt by penetrating the paint layer to make it more transparent, and so to change its colour, while it robs the painting of its distinctive mat surface. Moreover, the chief enemy of fresco is damp from behind and below, against which no surface layer is a protection.

# 6

## PAINTING PROCESSES: TEMPERA;
## THE METALS IN PAINTING

IN fresco, though a ground is prepared for applying the paint layer, the two are hardly distinguishable in the completed work. In *fresco secco* the lime water used as a medium is of the same composition as the ground; while in *buon fresco* the pigment is incorporated in the outer layer of the ground itself. Also, fresco when painted did not have a protective layer put over its surface, though later generations have sometimes tried to supply one.

In contrast, in the painting processes still to be described, those of tempera and oil, the paint layer is quite distinct from the ground and is often of different composition, and a protective layer is almost invariably applied. Thus, we are now concerned with the most elaborate form a painting can take.

*Tempera*. It has already been mentioned that this term is sometimes applied to various kinds of size painting. Historically, there is nothing against this. Cennino Cennini uses the word 'tempera' practically as the equivalent of 'medium', and writes of a size and of an oil tempera. In practice, however, and as the result of modern usage, it is better to confine the term to that form of painting in which the medium is egg. In medieval Europe this was the medium most extensively used for painting on wood panels, until in the course of the fifteenth century it was displaced by various types of oil and varnish media. Very occasionally, egg tempera was used on linen or canvas; but in the Middle Ages, paintings with textiles as supports were generally for temporary purposes, such as banners and decorations at religious and other festivals, and as noted above, the medium in such cases was

likely to be some form of size paint. Especially was egg tempera used in Italy; and in that medium, the great altar-pieces and smaller panel paintings of the fourteenth and earlier fifteenth century were carried out. It is not surprising, therefore, that the standard account of how to use tempera in its most elaborate form is that given by Cennino Cennini (see the previous chapter on Fresco). It is, indeed, largely due to him that, after long disuse, there came a revival of tempera painting, which continues today. In the earlier nineteenth century, reflecting a revived interest in early Italian painting, Cennini's treatise was rediscovered and transcriptions and translations into various languages were made, thus putting at modern painters' disposal an exact and authoritative account of early Italian methods.

Invariably, in tempera painting, the wood panel has to be prepared to receive the paint. Even if carefully planed and sandpapered, it is apt to be uneven in texture, due to knots and inequalities in grain, and so would absorb the paint unevenly; while resins in the wood would certainly in time soak into and discolour the paint. To the panel, therefore, a ground of gesso (a mixture of size and plaster of Paris) was applied. First, however, Cennini recommends that the panel be given a coat of size, saying: 'And do you know what the first size, with water, accomplishes? Not being so strong, it is just as if you were fasting, and ate a handful of sweetmeats, and drank a glass of good wine, which is an inducement for you to eat your dinner. So it is with this size; it is a means of giving the wood a taste for receiving the coats of size and gesso.'[1] The next step was to fasten to the panel with size thin linen or canvas, in strips if the panel were large. This had a double purpose; it provided a finely toothed surface to which the gesso could adhere, and it provided further protection against resins from the wood discolouring the gesso or the paint. The gesso was applied in several coats. The earlier ones were what Cennini calls *gesso grosso* (thick gesso), which consisted of plaster of Paris mixed with size made from parchment clippings. Plaster of Paris is calcium sulphate prepared by roasting gypsum or alabaster. When mixed with a little water or size, it crystallizes into a hard

---

[1] The translation is from Thompson, op. cit.

mass, familiar to everyone in the form of plaster casts. Every layer of
gesso had its surface carefully smoothed, but the *gesso grosso* always
had a slightly granular surface, to which the next coat of gesso could
adhere firmly. The gesso ground was finished with a layer or layers
of *gesso sottile* (thin gesso), as Cennini calls it. This is prepared by
mixing plaster of Paris with a great deal of water, which prevents it
setting, and reduces it to a very fine powder, which in Cennini's
words, 'will come out as soft as silk', and is then mixed with size.
Finally, the *gesso sottile* was scraped as smooth and flat as possible with
a knife.

For large paintings, several pieces of wood had to be joined to-
gether, and this was done with a glue made by mixing cheese with
quicklime, a homely blend that time has proved to be both effective
and permanent. In the Middle Ages, also, it was usual to make panel
and frame together, the frame in the case of larger altar-pieces being
as a rule elaborately carved. That is why, to his description of pre-
paring the panel, Cennini adds instructions for covering the frame
also with *gesso grosso* and *gesso sottile* to prepare it for being gilded.

Even in Cennini's time the elaborate procedure he details was some-
times simplified, as it often is today. He himself, in the case of small
paintings, says that it is enough to size the panel, and put on several
coats of *gesso sottile*; and modern restorers, when they have had to
transfer a tempera painting from an old and decayed panel to a new
support, generally find that the canvas or linen under the gesso, and
the layers of *gesso grosso*, are only used in the case of large panels
composed of several pieces.

The gesso, too, was not necessarily made from plaster of Paris. In
Cennini's time, according to his own account, wood ashes mixed
with size might be substituted for the *gesso grosso*. Again, chalk
(whiting) can be used throughout instead of the plaster, as com-
monly happens today; while today, also, canvas is sometimes used
as a support instead of wood. But no substitute gives quite so firm
and smooth a surface as plaster of Paris, nor does canvas give so firm
a foundation to the gesso as does wood.

For painting, powdered pigments are mixed, at the time of paint-

ing, with egg yolk alone, or with both yolk and white. These are composed of the same substances, though in very different proportions. In the white, the binding element is albumen and there is very little fat, and by itself it forms a brittle film, soluble in water. The yolk, however, contains a considerable proportion of oil as well as albumen; and these together dry into a tough film, hardly soluble in water. Anyone who has tried to wash an egg spoon some time after use will know this. A mixture of white and yolk naturally increases the proportion of albumen in the medium, and so makes it somewhat more brittle, and more liable to be affected by water.

Both white and yolk contain large proportions of water; but it is usual to add water as a diluent, to make the paint easier to work. For the same reason, a little vinegar used to be added to the yolk, since this made it somewhat less greasy. Today, a little acetic acid is sometimes used for the purpose. In both white and yolk is a fatty substance called lecithin, which also contributes to easy working, by helping to emulsify (i.e. make into a mixture substances otherwise repellant to mixing) the oil and the non-fatty parts of the medium.

Tempera dries quite quickly, even when considerably diluted with water. Mixed with a pigment its transparency is between transparent water-colour and oil, and cannot be relied upon to conceal anything underneath it. Consequently, modifications and corrections are difficult to make, once the paint has dried. This has several consequences in practice.

Almost invariably, before painting begins, a detailed drawing of the subject is made on the gesso. Cennini, for example, advises that the drawing be first made in charcoal, practically effaced, and then gone over with ink and a brush, the remains of the charcoal then being brushed away. Preparatory to this drawing would, of course, be a number of other drawings and studies, similar to those made in preparing a cartoon for fresco. On the basis of this drawing, the paint is built up in a series of layers, much in the same way as in transparent water-colour. Frequently, the system of light and shade was indicated by a wash of *terre verte* (green earth colour), over which the other colours were laid, light at first, to be strengthened and

enriched by subsequent layers, if required. This green underpainting is often to be seen in fourteenth-century paintings, especially in the shadows on the flesh. In Plate XV *a*, a detail of a fourteenth-century Sienese painting, both the underlying drawing and the *terre verte* lay-in of the shadows can be seen. For the underlying drawing see also the head of an angel from a painting by Cosimo Tura (Pl. XV *b*). Over this green underpainting, the forms would then be fully modelled, and details added by smaller touches of paint. These touches were not fused but laid side by side, like hatching or stippling in water-colour, since the paint, having to be thick enough to allow precision of touch and density of substance, dried quickly, and so did not allow one touch to melt into another easily.

When the painting was finished, and thoroughly hard and dry, varnish was applied both as a protection, and to improve appearance. Cennini recommends waiting as long as possible before varnishing and adds, 'if you varnish after the colours and their temperas have run their course, they then become very fresh and beautiful, and re-main in pristine state forever'. Cennini does not give a recipe for his varnish; but it was apparently not free-running, since he speaks of its being applied with the hand or a sponge, which suggests a resin dis-solved in a drying oil, of the kind described later in the section on oil painting. In modern practice a coating of wax is often used to protect the surface of tempera paintings.

Various methods have been used to retard the rapid drying of tempera, and so give it greater malleability.[1] Free use of water does something, but makes tempera somewhat like transparent water-colour in use, and is not practicable in the final stages of a painting. Some modern recipes therefore recommend the addition to the egg of a considerable quantity of oil. This certainly retards drying, and probably toughens the paint film (though this is hardly necessary); but the oil is liable to turn yellow, which may explain why some modern tempera paintings have darkened and discoloured.

In addition to difficulties of manipulation, tempera has similar,

[1] Eastlake suggests that honey or perhaps wax was mixed with the paint for this purpose.

though less marked, limitations to those of fresco. The albumen in both the white and yolk of egg contains sulphur, which in contact with pigments containing lead or copper, such as white lead or verdigris, may cause formation of black sulphide of lead. The range of tone in tempera, though greater than that in fresco, is less than that in oil, and marked variations in the thickness of different parts of the paint layer are not possible, so that the painter has fewer means of securing dramatic emphasis than in oil. But in luminosity and subtle delicacy of colour, and in beauty of texture, tempera is one of the most remarkable processes available to the painter. Moreover, its results are very durable. The medium encloses and protects the pigments well, and is not itself liable to disintegrate or to change in colour and transparency.

It is a much disputed question whether tempera paintings were intended to be seen as they now appear in many museums, the paint covered only with a thin layer of wax or colourless varnish with a dull surface, which does not affect the quality of the colours and the high key. It has been argued that the varnish of which Cennini speaks was intended both to increase the richness and depth of the colours, and to give the whole painting a mellow tone. Certainly, in paintings where the underlying modelling is in the dull green of *terre verte*, a varnish toned slightly yellow gives what is, to some modern eyes, a more harmonious and unified effect. Cennini says nothing about toning his varnish, though there is reason to believe that in any case it was dark and yellowish. The reasons he gives for its use are that it gives the colours freshness and beauty and preserves them. If this means, as it may mean, that the varnish gives the colours the appearance they had when first applied and still wet, then the case for the early painters using what was in effect a toned varnish is strengthened, since the varnish would have just this effect. However, we are unlikely ever to know how the medieval painter intended his tempera painting to look; since in the rare cases where a painting retains some of its early varnish, and this has not been covered by varnish of a later date, the early varnish is so discoloured and fragmentary as to give no clue to what it originally did for the appearance of the painting.

*Metals* applied to the surface of a painting, and so virtually serving as pigments, are rarely seen except in medieval work. There, they played a very important part in manuscript illumination and in panel painting, and occasionally in fresco. They were also used to a limited extent in the later fifteenth century, but they were so tied in with medieval purposes and practice, that with the development of oil painting in the sixteenth century their employment practically ceased.

The metal chiefly used was gold. Silver sometimes occurs, however, examples being its occasional use for the armour of figures in the paintings on Italian *cassoni* (chests) and for backgrounds and decorative details in northern paintings of the thirteenth and fourteenth century. Probably in these latter the silver served as a substitute for the more expensive gold; and was covered with a layer of yellow varnish both to give it the necessary colour and to protect it from the air. In fact, even if such varnish was used, it did not remain effective; and almost invariably the silver has turned black owing to the formation of silver sulphide from impurities in the atmosphere. A famous example are the censers held by the angels in the thirteenth-century Chichester Roundel, already mentioned. Very occasionally, too, tin covered with yellow varnish was used as a cheap substitute for gold, but has proved equally likely to disintegrate. Gold in contrast, neither tarnishes nor decays, and even when encrusted with dirt can be cleaned and restored to its original brightness, while in use it has a lustre and richness beyond that of other metals.

Whatever the metal, however, the methods of use are the same; so for the sake of simplicity, the following description is confined to gold.[1] This is used chiefly in two ways: (1) ground into powder, mixed with a medium, and applied as *gold paint* with a brush; (2) beaten into a very thin sheet, known as *gold foil* in its thicker form, and as *gold leaf* when at its thinnest. A third method, described in medieval handbooks, is to cover the area to be gilded with some substance like powdered glass mixed with a medium, which when dry provided a surface like fine sandpaper, and on this to rub a piece

[1] The following account owes much to Thompson, op. cit.

of gold. How far this method was in fact used is, however, impossible to say.

The trouble in using powdered gold is making the powder. The tendency is for particles of gold under pressure to adhere to each other, and the more they are pounded, the coarser the powder becomes. So the medieval craftsmen invented various ingenious ways of overcoming the difficulty, such as mixing the gold with honey to keep the particles separate, and then washing the honey away. In any case, the tendency of the gold particles to come together could be exploited in the process of painting. When first applied, the gold paint did not look very different from yellow paint; but when *burnished*, i.e. rubbed with a hard, very smooth surface, larger particles were formed, and the gold would begin to glisten. Among the chief uses of gold paint was that of writing in illuminated manuscripts. Also, in these and in panel paintings, it was sometimes used for putting in the delicate details and highlights. Examples of this often occur in paintings of the later fifteenth century, such as those of Geertgen tot Sint Jans, Mantegna, and Giovanni Bellini. Sometimes the gold powder would be mixed with other pigments, to give sparkle and luminosity to the paint; and Cennini recommends its use in this way when painting foliage, 'if you want to make a tree to look like one of the trees of Paradise'.

But the more usual method of using gold was in the form of gold leaf, applied by means of a sticky substance known as a *mordant* (literally something that bites, but by analogy, something that catches hold of the gold).[1] The mordant was applied to the area to be covered, the gold leaf laid upon it, and any superfluous gold brushed away. Often, the mordant had some pigment mixed with it, partly because this made it easier to see exactly where it had been applied, but also because the colour beneath the thin layer of gold, which is semi-transparent, gave it greater richness. A colour frequently used was *bole*, reddish earth often called Armenian bole from one of its sources of supply, which gave the mordant a pink colour. With the

---

[1] The mordant could either be an adhesive soluble in water (e.g. glair or size) or a resin dissolved in oil to make an oil varnish.

mordant was sometimes mixed a filler, such as chalk, which enabled a thicker layer to be applied, and slightly raised the gold, giving the impression of a thicker layer of gold. When the gold had been applied, it could be burnished by rubbing it with some hard, very smooth substance, such as an animal's tooth in the case of illuminated manuscripts, or certain kinds of stone for larger surfaces. This polished the surface of the gold, and increased its reflecting power so that it picked up shadows as well as lights; and burnished gold, therefore, looks not only more brilliant but darker than unburnished. This, joined to differences in the colour of the mordant, mainly accounts for the different appearance of gold in different paintings, or in different areas of the same painting. The larger the size of the surface of the burnisher in relation to the area of the gold, the more even the result; but the high degree of technical perfection thus achieved in the fifteenth century often led to a monotonous brassy quality in the gold, compared with the liveliness and variety due to small inequalities of surface in earlier work.

Both in illuminated manuscripts and in panels gold leaf (as distinct from paint made from powdered gold) was chiefly used for backgrounds and haloes, and for the decoration of robes and accessories. In manuscripts it was also extensively used for lettering, especially large initials. In fresco its use was restricted to haloes and decorative details, since the amount of gold required for backgrounds would have cost too much. The gold leaf was applied after the drawing had been made on page or panel, but before any colour was used, except in the case of intricate and delicate detail, for which, however, gold paint was more likely to be used. Usually, the area of the gold would extend a little over the edge of the areas which were to be coloured. Then the gold could be either scraped away to the exact line up to which the colour was to come, or the paint layer would overlap the gold where necessary. The process can be well studied in certain unfinished manuscripts, among them the Metz Pontifical in the Fitzwilliam Museum, Cambridge (Pl. XII) where pages in different stages of the work occur. The overlapping of the gold by the paint at its edges, has given rise to the idea that the painting was sometimes

carried out on a gold ground. Not only was this unnecessary, but it would have been very costly, especially where large panels were involved. Also, paint does not adhere very well to a gold surface, and is liable to chip away. For this reason, where the paint was carried over the gold, the part of the latter to be painted would sometimes be covered with a mixture of size and white pigment, but even so, chipping can often be seen at the edges. Similarly, where a pattern in colour was put on to a gold ground, as was sometimes done in the case of robes, haloes, and ornaments, the colour has often fallen off in places.

Though in principle the use of gold for manuscripts, panels, and in fresco was similar, in details practice was somewhat different. In illuminated manuscripts, the mordant was invariably a water mordant, applied direct to the parchment, any colour required under the gold being mixed with the mordant. Here there were certain difficulties to be overcome, such as the over-quick drying of the mordant, generally met by mixing in a little honey or sugar, which are hygroscopic. This had the additional advantage of making the mordant a little more elastic when dry, and so less liable to crack under the pressure of burnishing.

In the case of panels, the main outlines of the design in the parts to be gilded were scratched in the gesso, partly as a guide for placing the gold, partly to indicate where any patterns or details which were to be painted on the gold were to go; and these incised lines can often be seen in the gold where it has been pressed down into the gesso. Next a layer of pigment (generally the reddish bole mentioned above, but sometimes of other colours) mixed with size was applied to the ground, instead of the colour being mixed with the mordant. The mordant was then applied, and finally the gold. The standard mordant used was an oil varnish. When, however, patterns or accents in gold were to be applied to a painted surface, involving fine lines and small shapes, some sticky vegetable juice seems generally to have been the mordant, unless gold paint put on with a brush was used. These juices were apt to hold the gold less securely than an oil varnish, and the gold will often be found to have flaked off

the paint. Another way of making patterns was to cover an area
of gold with paint, and while this was still wet, remove the paint
where required. Here again, the paint was liable to flake off, as when
it was carried over the edges of gold.

A very important element in the use of gold, much more frequent
in panels than in illuminated manuscripts, was *tooling*. By means of
pointed instruments of varying fineness and sharpness, the areas of
gold would be surrounded by an incised line, haloes and other forms
involving circles being struck with compasses, while for rectangular
forms, such as borders of backgrounds, a straight edge was used.
Within these outlines, again by the use of pointed tools, and by
metal dies, patterns of very varied types were made in the gold.
Sometimes the use of the same type of pattern or of the same dies
can be recognized in different paintings, and helps to tie them down
as coming from the same workshop. Great care had, of course, to be
used not to break through the surface of the gold, and reveal the
gesso beneath. Tooling was of the greatest value to the medieval
painter, since not only were the patterns themselves an enrichment,
but, by presenting different facets of the gold surface to the light, it
increased glitter and the feeling of light radiating from the painting.

# 7

## PAINTING PROCESSES: OIL PAINTING

WHEN a painting is described as being in encaustic, pastel, water-colour, or fresco the idea is conveyed not only of certain definite materials being used, but of fairly well-standardized methods of using them; while there comes to mind some tolerably clear notion of the appearance of the painting. This holds good even for tempera, despite the confusion between egg tempera, size painting, and the difference in appearance that a coat of varnish may produce. But when a picture is said to be 'painted in oil' the case is very different. In the long history of oil painting, the range of materials has been so wide and these have been used in so many different ways, that results widely different in structure and appearance have been produced. A spectator confronted by examples of, say, the fifteenth-century Flemish School, the sixteenth-century Venetian School, and the French Impressionist School, and being told that they are all 'oil paintings', might well wonder whether the term has any meaning. In fact, the only justification for grouping such diversities under one technical heading, is that oil, in some form or in some way, has played a considerable part in their making.

Before, however, discussing the different uses of oil at different periods of oil painting, a few definitions are desirable. The oils used in painting are the 'drying oils'. The term 'drying' has not the same significance as when used in domestic washing; but means that the oil when exposed to the air is changed into a hard substance as a result of oxidization combined with certain obscure molecular changes. The contrast is with the 'non-drying' oils, such as castor and olive oil, which do not harden in this way. Best known and most widely used

by painters is linseed oil. Walnut and poppy-seed and other oils have been and are still used, but involve no substantial difference in methods or results. If a drying oil is mixed with certain metallic salts (e.g. those of lead), the process of oxidization is hastened, and these salts are therefore known as *driers*, and since the mixing is usually effected by heat the product is known as *boiled oil*. Artist's oils when first prepared are yellowish, and are therefore sometimes bleached by exposure to sunlight or by chemical means. One important point is that oils, especially linseed oil, may become yellow with lapse of time, though it is sometimes alleged that the oil can be so treated as to prevent this. In consequence, any painting in which oil has played a considerable part, is apt to become yellow or brown in tone as the oil changes colour. This helps to account for the 'old master' tone of many old pictures, which used to be so much admired that it was often simulated by applying a layer of transparent yellow paint.

An oil may sometimes be too thick for convenient manipulation, in which case it may be mixed with a volatile fluid such as turpentine or benzene, known as a *diluent*, to make it flow more easily, the diluent, of course, evaporating in time. This practice became more common with the increased use of ready-prepared paints, since when artists prepared their own oil and ground their own colours, the viscosity of the paint was largely under their own control.

Another important constituent in many oil paintings is *varnish*, used either as a medium, either by itself or mixed with oil, or as a protective coating to a painting. Varnish consists of a resin dissolved either in a spirit such as alcohol, turpentine, or naptha, and known as a *spirit varnish*; or in a drying oil, such as linseed, and known as an *oil varnish*. The resins used in the past cannot always be identified. They include, however, soft resins and balsams from living trees such as mastic, damar, sandarac, Canada balsam, and Venice turpentine; and hard fossil resins such as copal and amber. The extent to which these are soluble in oil or spirit varies, and on this, the type of varnish depends. Apparently spirit varnishes did not come into use until the sixteenth or seventeenth centuries; and before that, oil varnishes were the rule.

The early Italian painters, it may be noted, used to call the resin from which the varnish was prepared *vernix*, and the varnish itself *vernice liquida*; a distinction to be borne in mind in reading early recipes. In addition to the natural varnishes, as they may be called, are those prepared from synthetic resins, well-known examples being the vinyl resins. These have their chief employment in industry, but are today being used to some extent by painters, and to an increasing extent in the conservation of works of art. Ordinarily, however, the student of the history of painting is not concerned with them.

A third term which it is convenient to define here is *emulsion*. This is a combination of two liquids which in the ordinary sense cannot be mixed, such as oil and water. If these are stirred together, drops of the one will be suspended in the other; but if nothing more is done, the drops will come together, and the two liquids will separate. To prevent this an emulsifying agent is introduced into the mixture, which has the effect of surrounding the drops and preventing their coalescing. A familiar example of an emulsion is egg yolk in which particles of oil are suspended in albumen (see Chap. 6).

Three other terms concerned not with materials but with manipulation, which will often be used in the following pages, are *glaze*, *scumble*, and *impasto*. A *glaze* is a layer of transparent paint, through which the light passing to the surface beneath is reflected back, so that the colour of the glaze modifies that of the underlying colour. The essential characteristic of a glaze is its transparency, and not (as is sometimes said) the thinness of the layer. In glazing, therefore, the pigments used are mainly those which are themselves transparent. A *scumble* is also a layer of paint used to modify the colour of the surface to which it is applied. But the pigments used are opaque, so that this surface is partly concealed; and the main characteristic of a scumble is, therefore, that it should be thin enough for some light to penetrate it, and be reflected back from the surface beneath. *Impasto* (derived from the Italian *impastare*, to make a paste), is the term applied to a thick, opaque, area of paint which stands up above the surface to which it has been applied. For example, 'a heavy impasto in the lights' means that the high lights in a painting have been put

in with a solid mass of paint, which contrasts with the comparative smoothness of the rest of the surface.

One thing to be kept very clearly in mind is that 'oil painting' was not invented by any one person, despite what Vasari says about it in his life of Antonello da Messina in the *Lives of the Painters*. This account is worth quoting, since it is a useful starting-point for discussion. After mentioning the disadvantages of tempera, and unsuccessful attempts made to overcome them, he proceeds:

It happened, therefore, when matters stood at this pass, that Giovanni da Bruggia[1] set himself to try different sorts of colours; and being a man who delighted in alchemy, he laboured much in the preparation of various oils for varnishes and other things, as in the manner of men of inventive minds such as he was. Now, it happened upon a time, that after having given extreme labour to the completion of a certain picture, and with great diligence brought it to a successful issue, he gave it the varnish and set it to dry in the sun, as is the custom. But, whether because the heat was too violent, or that the wood was badly joined, or insufficiently seasoned, the picture gave way at the joinings, opening in a very deplorable manner. Thereupon, Giovanni, perceiving the mischief done to his work by the heat of the sun, determined to proceed in such a manner that the same thing should never again injure his work in like manner. And as he was no less embarrassed by his varnishes than by the process of tempera painting, he turned his thoughts to the discovery of some sort of varnish that would dry in the shadow, to the end that he need not expose his pictures to the sun. Accordingly, after having made many experiments on substances, pure and mixed, he finally discovered that linseed oil and oil of nuts dried more readily than any others of all that he had tried. Having boiled these oils therefore with other mixtures, he thus obtained the varnish which he, or rather all the painters of the world, had so long desired. He made experiments with many other substances, but finally decided that mixing the colours with these oils, gave a degree of firmness to the work which not only secured it against all injury from water when once dried, but also imparted so much life to the colours, that they exhibited a sufficient lustre in themselves without the aid of varnish, and

---

[1] Jan van Eyck, born at an unknown date at Maaseyck in Flanders, who died at Bruges 1441. The founder and one of the greatest painters of the early Flemish School.

what appeared to him more extraordinary than all besides was, that the colours thus treated were much more easily united and blent than when in tempera.

Vasari then goes on to tell how other Flemish painters adopted Van Eyck's methods; how a Flemish painting sent to Naples was seen by Antonello da Messina, who went to Flanders and studied with Jan van Eyck; and how Antonello, having settled in Venice, communicated 'the secret method of painting in oil' to another painter, from whom the knowledge spread in Italy.

Much of this dramatic and entertaining account can be proved to be incorrect, while the description of Van Eyck's procedure is not precise enough to be useful. But it contains, nevertheless, a solid core of truth. Jan van Eyck's methods heralded a revolution in the technique of painting in Europe; and Antonello da Messina was certainly one of the channels through which knowledge of those methods came to Italy. What Jan van Eyck achieved may be easily seen from comparing a Flemish fifteenth-century painting, such as one by Jan van Eyck himself, or by Roger van der Weyden, Hugo van der Goes, or Hans Memling, with an Italian painting of the earlier part of that century. The Flemish painting will be seen to be richer and denser in colour with a wider range from darks to lights; to have the modelling of the forms more fused, with more subtle transitions, while its detail is more elaborate and precise. Moreover the condition of most Flemish paintings is in general better than that of contemporary Italian work, especially as regards preservation of the colours. These differences, of course, have no necessary connexion with the merits of the paintings as works of art; but they reveal that technical developments had taken place which put new resources into a painter's hands, and increased his powers of expression. The problem is, what exactly was the nature of these developments? In the two points mentioned by Vasari, van Eyck was no pioneer. He was certainly not the first painter to use oil, since recipes for the preparation and use of this in painting exist from the twelfth century, and payments for oil appear in various medieval accounts concerned with painting. Neither was the use of varnish as a medium unknown, since recipes

which involved this existed before Van Eyck's time. All the evidence points, as Vasari hints, to Van Eyck's innovations consisting in the way he prepared materials in current use, and how he used them. But over the nature of these innovations there is difference of opinion. One group, of which Eastlake is a formidable representative, finds the key to Van Eyck's methods in the use of a hard, clear, quick-drying, resinous varnish, which was mixed with oil to provide a medium, and was also used as a final protective coating. Laurie on the whole supports this point of view, though he points out technical difficulties, to meet which he seems to favour the idea of a complex series of paint layers in which various mixtures of oil and varnish were used. Others hold that Van Eyck used a much more complicated medium, consisting of some form of tempera emulsified with oil, at least at some stage of the painting. Recent scientific investigation, however, has proved that the basic medium was a drying oil.[1]

The method of using the medium is also in dispute. One thing seems reasonably certain, that on a gesso ground Van Eyck first made an elaborate drawing as did the tempera painters. An example of this is the painting of St. Barbara in the Antwerp Museum (Pl. XVI a) which is carried out entirely in monochrome; though that colour was to be applied to it is indicated by some blue in a corner of the sky. Fortunately, this is not the only example of such a beginning. In the Uffizi Gallery, Florence, is a *Mourning Over the Dead Christ* attributed to Giovanni Bellini, carried out in black, in general regarded as the basis for subsequent painting, though this has been denied.

How the colour was applied to such a drawing is where differences of opinion arise. One view is that Van Eyck and those using his methods first used tempera, and then glazed with colour in varnish or some special medium. Some support for this view is given by an unfinished *Virgin and Child with Saints*, attributed to Cima da Conegliano, in the National Gallery of Scotland (Pl. XVI b). Here is a detailed drawing on gesso; a lay-in of tempera; while over part of the sky is laid a scumble of tinted oil paint. Whatever was Italian

[1] Cf. Coremans, Gettens and Thissen, *La technique des Primitifs flamands* in *Studies in Conversation* I, no. 1, 1952.

practice, however, the investigations mentioned above have shown that the fifteenth-century Flemings used oil throughout, without tempera.[1] In any case, it is certain that the painting was not what is called 'direct painting', in which the paint is given from the beginning as far as possible the colour and texture it is meant to have in the finished work. Instead, the paint was applied in layers of varying transparency and colour, and the final result depended upon the combined effect of these layers.

The extent of the technical triumph of the early Flemish painters may be judged by comparison with the results of some experiments in fifteenth-century Italy. There, too, painters had become dissatisfied with the limitations of tempera and fresco. An example of the devices used in an attempt to evade these is given by the Florentine, Alesso Baldovinetti (1425–99) described by Vasari. When painting a chapel in Santa Trinità in Florence,

Alesso sketched the stories in fresco, but finished them *a secco*, tempering [i.e. mixing] his colours with the yolk of eggs mingled with a liquid varnish, prepared over the fire; by means of this vehicle he hoped to defend his work from the effects of damp, but it was so exceedingly strong, that where it had been laid on too thickly the work has in several places peeled off; and thus, when the artist thought he had discovered a valuable and remarkable secret, he found himself deceived in his expectations.

We know from Cennino Cennini and other sources, that the Italian painters were familiar with varnishes, but these in Cennini's day seem to have been made from oil and were thick, dark, and slow drying—mostly used for covering tempera paintings. The interesting point about the passage from Vasari is that apparently Baldovinetti introduced varnish, and therefore oil, into his medium; and he was certainly not alone in doing this. Many Italian paintings of the fifteenth century will be found to have their darker parts raised above the surface of the rest of the paint, and it seems highly probable that this was due to mixing oil varnish with the medium. Such practices were transitional, and paintings of this period cannot properly be described

[1] See also Ziloty, *La Decouverte des Van Eyck*, 1941, who comes to the same conclusion and suggests that turpentine was used to thin the oil.

as oil paintings, but only as those in whose making oil played some part. At this period in Italy earlier procedures which had been standardized and became widely employed were either forgotten or neglected, while new ones had not been evolved. Thus great varieties of practice were possible, and manuals of instruction, which might have told what was being done, were not written. Soon, however, as the result perhaps of Flemish example, or perhaps of independent experiment, knowledge of a comparatively colourless and more freely flowing oil must have become general in Italy, until in the early sixteenth century the use of oil in painting was firmly established. Indeed some Italian writers of the later sixteenth century speak of the Flemings retaining the use of tempera, while the Italians used an exclusively oil technique.

Be this as it may, it is very important to realize that from then onward oil was not necessarily the only medium, but might be mixed with other substances, especially the resinous varnishes, or emulsified with some aqueous liquid. Moreover, layers of oil paint often formed only part of a painting, being combined with layers in which other media, notably tempera, were used. Until the nineteenth century an oil painting was an elaborate structure in layers, consisting usually of an underpainting, to which were added glazes and scumbles, on top of which the painter would put the lights, and add any necessary details. The underpainting would usually be in monochrome, with the design of the painting fully worked out, and the forms fully modelled except for the lights. The scumbles and glazes would add colour, would give richness of texture to the paint, would enable all kinds of variations and subtleties of modelling to be introduced, and by the reflections through them from underlying surfaces give rise to what the English painter J. C. Ibbetson used to call 'inner light'. Lights would then be put in with opaque paint, sometimes of considerable thickness, and opaque paint would be used for adding details, including the sharpening of shadows or introducing a reflected light into them. The use of a heavy impasto, impossible in tempera and fresco, in itself made possible an increased scale of tone relations, since striations and furrows in the paint intro-

duced variations of tone into the impasto itself. Moreover, the opposition of loaded lights and transparent passages helped to give a sense of depth within the painting.

The procedure outlined above, of course, varied considerably in the hands of different painters, but always much use was made of the different opacities of paint. The final painting was by no means always the principal one, as it usually was in the nineteenth century. What lay underneath this last layer might be of equal or even greater importance from its influence on the total effect.

The development in the use of oil brought about considerable changes in supports and grounds. Panels, which had been mainly used in tempera and size painting, still retained popularity, especially in northern Europe and among the painters of Germany and the Netherlands in the sixteenth and the seventeenth centuries. Such panels were generally of hard, close-grained wood such as oak, which was easily available. In Italy, however, panels were more rarely used, and were then as a rule of softer wood, obtainable locally. Indeed, a useful pointer to a painting's place of origin may be the wood on which it is painted. Metal, chiefly copper and zinc, was also used for supports, generally in the North, rarely in Italy. Wood and metal, however, were mainly restricted to small paintings; and the material whose use became practically universal among painters in oil was canvas.

The ground on a panel or sheet of metal might be the gesso of the tempera painters. This, however, was highly absorbent, and tended to suck the oil out of the paint, so that it had to be treated to make it less so, e.g. by the application of size. Ultimately, however, the grounds used on panels and metals approximated to those employed on canvas; and in the hands of some Dutch painters were reduced to little more than a priming of size or oil paint to make the wood less absorbent, with the result that the grain of the wood can often be seen through the paint. Gesso was also used on canvas; but apart from being absorbent it was liable to crack owing to movements in the canvas. Consequently, mixtures in which oil played a considerable part, combined with white pigment or with such substances as whiting and china clay, came widely into use, the canvas generally being

sized before the mixture was applied, to prevent the oil being absorbed. These grounds would vary in absorbency according to the amount of oil or size they contained. The exact composition in any particular case is impossible to determine without chemical analysis; but it is important to remember that the nature of the ground on which he paints gives the artist a potential means of influencing the appearance of his picture, since the amount of oil it may absorb determines how much is left in the paint itself, so helping to determine whether the paint dries dull or glossy.

More important still, in its effect on the ultimate appearance of a painting, came to be the colour of the ground. This could be determined either by mixing colour in the ground, or by use of a coloured priming; and it could range from white to a dark grey or a dusky red; and the painter in oil who had used transparent and semi-transparent paint often relied as much upon the effect of light reflected from the ground through his paint, as did the painter in tempera or water-colour. Even when the paint applied to the ground is opaque and covers it entirely, as in many nineteenth-century paintings, the colour of the ground is apt to have its influence, by appearing in the interstices between brush-strokes, or by being seen through patches of paint which by accident or through lapse of time are not entirely opaque.

But perhaps the two most important developments due to the use of oil in painting, were the wider range of tones available and the increased number of pigments. In fresco, tempera, and water-colour, the gamut of tone—the range from dark to light considered independently of colour—was restricted to the upper register; the painter in oil had at his disposal a sequence of darks extending down almost to black.[1] Indeed, in the later sixteenth and seventeenth centuries, it almost became a characteristic of oil painting for these lower tones to be used over the greater part of the canvas, lighter ones being reserved for occasional sharp and dramatic oppositions; so that Caravaggio and those influenced by him are sometimes known as

[1] It should be noted that black in a painting rarely, if ever, *looks* black owing to reflections from the surface.

the *tenebrosi* (the gloomy men). As regards pigments the increased number available was largely due to scientific research; but the fact that oil and varnishes could more effectually protect pigments from the effects of atmosphere, or interaction between themselves, is also partly responsible. A famous example of this is the brilliant green of the dress of the lady in the portrait of Jan Arnolfini and his wife, by Jan van Eyck, in the National Gallery, London. Apparently no pigment known at the time could have yielded this green except verdigris, a notoriously unstable substance. Yet Jan van Eyck's medium has so perfectly protected it, that it is probably as brilliant as it ever was.

The best way to grasp how varied were the procedures of oil painting in the seventeenth and eighteenth centuries, and yet how firmly they were based on certain general principles, is to take examples. It is, however, unwise to dogmatize overmuch as to the materials and methods of painters in the past, unless there are reliable contemporary records; and as these rarely exist, and if they do may be difficult to interpret, over-precise accounts of how this or that painter worked are generally to be distrusted.

Broadly speaking, painters tended to fall into one of two groups according to whether they began with a light ground or with a dark ground. This difference appears even as early as the sixteenth century. As was to be expected, northern painters were strongly influenced by Flemish example. Holbein, for example, seems to have made a careful line drawing on the white priming of his panel or canvas, with some indications of modelling.[1] Possibly this drawing was washed over with a tone; in any case, the modelling was developed in monochrome, perhaps with black or burnt umber, and the painting completed with glazes and solid paint.

In Florence the general practice was to use a light ground. An early example is the unfinished *Adoration of the Magi* by Leonardo da Vinci, commissioned in 1481 (Pl. XVII *a*). In this Leonardo seems first to have put a warm tint over the ground, sketched in the subject

[1] There seems every probability that this, certainly in the case of a portrait, was not made from life, but from a drawing.

with pale grey-green, then to have elaborated the drawing in brown, with which the shadows were indicated, these in some cases being strengthened with darker grey-green (probably a *terre verte*), while some lights are picked out in white. Here then, are seen all the stages of the preparatory lay-in. An example in which later stages are represented is a *Holy Family* of the first part of the sixteenth century, belonging to the Courtauld Institute, London, formerly attributed to Fra Bartolommeo, now given to Pierino del Vaga (Pl. XVII *b*). The figures of the Virgin and St. Joseph are elaborately drawn with a brush and a reed pen directly on a gesso ground, and the main masses of the light and shade are suggested in brown monochrome; in the hands of the Virgin a glaze has been put over the drawing, leaving this still visible; while the bodies of the children reveal a further stage in that the shadows have been hatched, and glazes and scumbles of opaque paint used in the lights. A third Florentine example is the famous *Entombment* by Michelangelo in the National Gallery, London. Here, the painting is more nearly finished; but in certain passages, notably the seated figure on the right, can be seen the preliminary drawing on a light ground, and an indication in *terre verte* of the main masses of light and shade. The standing figure on the left has the robe painted in tempera; while in certain parts scumbles and glazes have been used to complete the painting. The apotheosis of the method followed by the Florentines is in Raphael, with his close-knit and smooth texture of paint, and his reliance on the light ground to give luminosity.

In contrast are the Venetians. Apparently for a time they also started with a light ground. This was to be expected, with Flemish and other northern influences powerful in Venice. An example by Giovanni Bellini has been cited; another, of the next generation, is the unfinished *Portrait of a Lady* (said to be Laura Querini) by Palma Vecchio in the Querini-Stampalia Collection, Venice. Here, in the head and neck especially, can be seen the careful drawing on a light ground, with slight monochrome modelling, over which the pattern of a brocade dress has been boldly laid in.

Eventually, however, the Venetians largely abandoned the use of

a light ground, and used a dark ground in preference. It has been suggested that this was in part due to the development in Venice of the use of canvas for large decorative paintings, which stimulated the use of canvas generally, and abandonment of the use of a white gesso ground. Certainly the use of a dark ground permitted work to be executed more quickly, since the ground itself could play a considerable part, either unchanged or slightly modified by a glaze or scumble, in the final appearance of the painting.

Titian, Tintoretto, and Paolo Veronese all exploited the dark ground in this way, especially in their larger canvases. Titian seems to have used sometimes a brownish or reddish ground, on which he built up a more or less monochrome under-painting, using the ground to form the shadows, and dragging a cool grey over this for the half-tones. Sometimes, however, there are indications that the ground was grey and supplied the half-tones, while the shadows were put in with warmer colour. Over this first painting scumbles and glazes were used to give colour and enrich the modelling, the lights being dragged on or sharply impastoed. Sometimes, apparently, a scumble of white would be put on to receive a glaze. Something of these methods can be seen in the detail (Pl. XVIII *a*) from the group of the *Vendramin Family* by Titian in the National Gallery, London.

Substantially, Tintoretto and Paolo Veronese used the same methods. How economical of effort was Tintoretto's painting in his maturity, may be seen from the portrait in Milan (Pl. XIX) where the ground has supplied most of the half-tones, the darks are intensified by glazes, and the lights put in with touches of varying density over glazes and scumbles to give the flesh colour and the colour of the robe. As regards Paolo Veronese (Pl. XVIII *b*) a micro-photograph gives some certainty in one particular case revealing that in an orange drapery there was first a white layer (the original ground), a grey layer (probably the priming) and an orange layer, apparently a glaze. In other paintings by him this grey ground or underpainting also appears, and sometimes forms the half-tones. A Venetian writer of the following generation says that Veronese used a green middle tone. Traces of this can sometimes be seen, though ordinarily the

effect is that of a grey, perhaps sometimes due to glazing or dragging over the green a warm tint.

A matter of controversy is the extent to which the Venetians used oil. It is said, for example, that their underpainting was in tempera and that for the later glazes and scumblings resins were used freely; in other words, that they substantially followed early Flemish methods. Other writers, however, hold that they used oil very freely; and this view has some support in contemporary records that it was usual to put paintings in the sun, which not only hastened the drying of the oil, but helped to bleach it.[1] But whatever the doubts as to details of Venetian practice, and the variations in method of individual painters, it is the Venetians who first exploited systematically differences in surface quality, texture, and thickness of paint. The ideal of a smooth, unified surface which had hitherto held sway, now had a formidable rival which gave the painter new means of variation and emphasis. Just as the Flemings in the past had directly or indirectly influenced the Venetians, so in the late sixteenth and early seventeenth century these in turn served as models to the Northern painters, notably Rubens and Van Dyck, so that their influence spread throughout Europe. Nevertheless, the close-knit, uniform texture of paint continued to be the ideal of certain painters, and has remained so throughout the nineteenth century.

Though these two types of oil painting often yielded results very different in appearance and served different kinds of purposes, in structural character and in the methods that produced them, they were basically the same; and for some 200 years, these methods were practised throughout the Western world. Some painters reduced the process of painting virtually to a standardized recipe, used not only by themselves but by their followers. In the first half of the eighteenth century, for example, the English portrait painters and the Colonial painters of America, almost without exception followed the

---

[1] This practice inspired the story that when Titian's portrait of Pope Paul III was put in the sun on the roof of the painter's house, it was mistaken for the Pope himself. Here the Renaissance put forward a champion against Zeuxis, who painted grapes so realistically that birds are said to have pecked at them.

method of Kneller, which was based on using the first lay-in to
provide the half-tones, over which the lights, shadows, and local
colours were applied by a glaze, a scumble, or solid paint, and the
high lights put in last, often with a considerable impasto. With a
different palette, Boucher in France used much the same method,
though working with a lighter background than Kneller and keeping
his shadows more transparent by using only glazes for them. With
a limited number of colours employed, this reduction to a system
made for speed in working and certainty of result, though that result
might easily become dull and mechanical.

The greater painters, however, permitted themselves more elasti-
city in how they handled the various stages of the painting, and in
the way they were combined. Rubens was perhaps the finest crafts-
man of them all, and probably his paintings, when adequately
cleaned, are nearer to their original appearance than those of any
painter of the seventeenth and eighteenth centuries comparable in
stature. Frequently he used panels as a support, even for large paint-
ings; and these panels, especially the larger ones, were composed of
several pieces of such size and so arranged as regards direction of
grain, as to provide compensations for movement, and so keep the
whole panel from warping. On this, or on linen or canvas, a white
smooth ground was laid. This was important, since the basis of
Rubens's practice was to keep his shadows transparent, and to use
opaque paint only in the lights, thus exploiting the influence of the
white ground. Rubens's procedures in leading up to his larger paint-
ings were elaborate. He began with drawings of individual figures
and forms, and a small sketch of the whole composition, frequently in
monochrome touched with colour. On these a more or less finished
painting of moderate size was based, sometimes by Rubens, some-
times largely by studio assistants; and from this the final painting
was made, again frequently with the help of assistants. Thus, changes
or corrections in the final painting, which in view of Rubens's exten-
sive use of transparent paint would have been difficult to make,
could be avoided. Though use of a white ground was usual with
Rubens, he did not hesitate to modify it if it seemed desirable. In

many of his sketches he seems to have rubbed a pale transparent grey priming over the ground, and then to have painted in transparent brown, putting in local colour with more opaque paint, and the lights with a sharp impasto. At other times, and especially in larger pictures, he tinted the ground brown, either all over or in part; while sometimes he used red in the same way. Occasionally (a notable example being the *Chapeau de Paille* in the National Gallery, London), where he wanted great purity and transparency of colour, he covered the necessary section of the tinted ground with white lead. The painting was then built up with varying thicknesses of paint, the shadows being kept thin and transparent, the lighter parts being more loaded. Sometimes, Rubens enriches the shadow and gives the effect of reflected light by superimposed touches of crimson. Occasionally there is evidence of a glaze being used to enrich or modify a layer of more solid paint. The highlights are usually put in with a thick impasto; though the main body of Rubens's paint appears fairly even and smooth in texture. It should be clearly understood, however, that though Rubens was systematic, his methods were elastic, and the technique used in one painting or at one period of his career does not determine exactly how he painted another picture. With this warning in mind some enlarged details of the *Chapeau de Paille* may profitably be studied (Pl. XX *a* and *b*). In one showing part of the face, the brush strokes are on the ground, and are covered with translucent glazes; in another, showing the feather in the hat, the blue background (upper left) is on the ground, and the black, grey, and white of the feather are over the blue.

Rembrandt, in contrast with Rubens, seems to have used a dark ground, sometimes grey, sometimes brown. In the earlier stages of painting, he used warm browns and yellows. When the ground was grey he seems to have intensified the shadows with warm colours, leaving the grey ground to supply cool half-tones; when the ground was warm the half-tones seem to be put in over the warm underpainting. Local colours were obtained by glazing, scumbling, or the use of solid paint; and the lights were put in with a rich impasto,

the maximum use being made throughout of variations in texture and thickness. No more than in the case of Rubens should Rembrandt's method of painting one picture be taken as an indication of how he painted another. A detail from his *Woman Bathing*, in the National Gallery, London (Pl. XXI) gives some idea of his technique, especially of his handling of impasto. Though Rembrandt made many drawings as preliminary to a painting, he, unlike Rubens, did not use preliminary oil sketches or elaborated designs, but seems to have worked direct on the canvas. Most authorities consider that Rembrandt made free use of varnish as a medium, and it has been suggested that this was the cause of many of his pictures yellowing. The most recent evidence points, however, to his using much oil; and this might equally well account for yellowing.

The methods of two other painters, Hals and Velazquez, have given rise to controversy. At one time Hals was regarded as a master of direct painting—this is, of mixing the colour required at any point in his work and applying it to the canvas without modification. Now, however, this view has been changed to some extent. Hals, like Rembrandt, seems to have used a darkish warm ground. He then seems to have made his first painting in a cooler monochrome, which served for his half-tones, the shadows being painted over this, also the local colour and the lights. Always Hals exploits the possibilities of a rich impasto, and bold brushwork, to give variations in surface. Whether he used glazes or not is uncertain, though on the whole the evidence is against it. Certainly he simplified the methods of his day, even to the extent of dispensing with preliminary drawings and studies. Velazquez did much the same thing. Drawings by him are so rare as to suggest that he, too, usually developed his design direct on the canvas. In his earlier work he often used a dull red priming on his ground, which makes itself felt through the thinly painted shadows; later, though not always, he seems to have used a grey ground. Apparently, though he used scumbles, he rarely if ever glazed, and used opaque paint for his local colour, and modelled and introduced detail by adding white in varying amounts. Painting more smoothly, and giving a more uniform surface than Hals,

Velazquez nevertheless uses fully the possibilities of variations in brushwork, to give emphasis and variety.

One general problem that has been much discussed in recent years may be mentioned here; what medium was used by painters who relied on a rich heavy impasto in the lights? It is argued that oil is too free-flowing to allow such a rich piling up of paint as is seen in, for example, Rembrandt, and that in place of one decisive brush-stroke, pigment had to be applied in a succession of touches. Some authorities, e.g. Laurie, suggest the use of *stand oil*, which is oil thickened by heating; others, e.g. Maroger, argue that oil, after being boiled with various substances, was mixed with wax (by the Vene-tians) or combined in a particular way with mastic varnish and turpentine to form a jelly, used by later masters.[1] Despite this and other uncertainties as to the actual materials used, however, the broad conclusion must be that the so-called 'secrets' of the earlier painters, lay less in what they used than in how they used it. Whenever we come across an authenticated recipe for, say, a medium or varnish, or whenever there is a chance to investigate materials actually used, they seem to be comparatively simple. Knowledge was less that of a wide range of substances and a variety of mixtures, than of what could be done with the materials available, and the complexity of oil painting lay in the many ways these various possibilities could be combined.

Good craftsmanship is not always a safeguard against deteriora-tion, and many oil paintings no longer look as they did when first painted. One cause of this is a tendency to darken. Partly this is due to the oil itself, which as noted above has a strong tendency to yellow with age, a tendency which is increased by the use of certain pig-ments, and by damp and darkness.[2] The oil which yellows may not, however, always be that of the painter. During the eighteenth and

[1] See *The Secret Formulas and Techniques of the Masters*, trans. from the French. New York and London, 1948. Incidentally a book to be used with great caution; cf. a review by James Watrous, *College Art Journal*, 1949, p. 239.

[2] A widespread idea that light is injurious to oil paintings is incorrect. It may affect certain pigments imperfectly protected by the medium; but ordinarily, paintings are best treated as if they were human beings.

nineteenth centuries, especially, a favourite practice was *oiling out*, which consists in rubbing oil into a painting with the idea of replacing any oil used as a medium which may have disintegrated, and to give a glossy surface.

Another cause of darkening, which applies particularly to paintings on a dark ground, is the tendency for oil paint to become more transparent with age, so that the colour and tone of any layer beneath it has greater influence on the appearance.[1] This thinning of oil paint has, however, other consequences which affect all paintings, and not only those in which the painter has worked from dark to light. At some stage in his work, the painter may have made changes, such as altering the position of a head, or changing the folds in drapery. When changes were made the earlier work was concealed, but with the thinning of the superimposed paint, they sometimes become visible, and are known as *pentimenti* (repentances). Sometimes what is revealed are not strictly *pentimenti*, but the preparatory stages in a work on which the painter has elaborated or refined. Thus, the preliminary drawing on the ground can sometimes be seen, particularly, for example, in early German painting, or parts of the preliminary lay-in. The frequency of true *pentimenti*, however, depends largely on the artist's methods of work. When he made a careful preparatory study of the design, and especially when this was in turn made the basis for an elaborate drawing on the ground itself, the likelihood of *pentimenti* is much reduced; while with artists who developed their design directly in terms of paint they occur more frequently.

Yet a third cause of darkening is changes in the colour of certain pictures. In the work of such painters as Caravaggio and the seventeenth-century Spaniards, who used large areas of dark colour, the details within those areas will often be found to be almost invisible, apparently owing to such pigments as the umbers having darkened. One particular pigment, which came into use especially among

---

[1] In more exact language, the refractive index of oil rises with age. This makes pigments mixed with it become increasingly translucent, so that they not only reflect less light, but enable light reflected from anything beneath the layer containing them to reach the eye more easily.

English painters of the eighteenth century, and was used spasmodically during the nineteenth, is asphaltum, also called bitumen, which is virtually the binding material used on road surfaces. This is a transparent brown, which used as a ground colour or as a glaze, at the time of using gives a rich, glowing quality. In time, however, it becomes almost black and increasingly opaque. Worse still, it never completely hardens, and eventually develops a network of roughly rectangular cracks, often wide and deep enough to reveal the ground beneath. Moreover, when used as a glaze, it may by its movement develop similar cracks in any underlying paint. So characteristic are these cracks of the work of certain English painters (Reynolds, for example) that they are often known on the Continent as *craquelure anglaise*.

. . . . . .

With the nineteenth century a great change comes over the practice of oil painting. It has been pointed out that there was a breakdown in the workshop tradition, which perhaps (as certain writers insist) has resulted in knowledge of certain materials and mixtures being lost, but certainly meant ignorance of the systematic procedures which had been handed down from master to pupil and assistant in the past. This is not the place to discuss the causes of that breakdown, but it may be suggested that the ideas of the romantic movement, with its insistence on the individuality of the artist, was a part cause; while new aims developed among painters, notably that of the expression of light, for which they judged the old methods unsuitable.

Speaking very broadly, the use of glazes and scumbles as part of a planned series of layers of paint was abandoned in favour of direct painting. Glazes and scumbles might still be employed, but more to bring a first approximation nearer to a desired colour, than to combine with an underlying colour to give the required result. For example, instead of putting a warm transparent colour over a green to produce a grey, the painter would start with a grey, and put a thin layer of another grey over it to get what he wanted. This was not merely another way of getting the same result, but involved some

loss of the richness and glow which the older method could yield. The nineteenth-century painter using direct methods did not, of course, necessarily finish off one part of a painting before going on to another, though it is recorded that a well-known portrait painter used to put over his canvas a sheet of paper in which a hole was cut, through which he completed in succession different parts of his picture. Ordinarily the practice was (and still is) to put in the main design of the painting in a colour scheme similar to that planned for the finished work, though each colour might be more subdued and perhaps higher in key, while extreme darks and lights would be avoided. Old painters have been known to advise students to get the ground covered as soon as possible, to avoid any disturbance of the general scheme by its whiteness; in other words, the ground was not intended to play an important part in the final result. Parts of such a 'lay-in' might be retained to the end, but more usually it provided a basis for one or more applications of opaque paint over each part, by which colours and tones were adjusted and detail added until the whole was complete.

There were naturally endless variations of the method so briefly and baldly described. Many painters were well aware of certain principles of early practice, but few of them knew how to apply them. When it is remembered that Sir Joshua Reynolds, an exceptionally learned painter, working in the eighteenth century, sought but failed to recapture Venetian methods, it can be realized how much more unlikely the nineteenth-century painter was to understand them. It was, however, a group of English painters of which Lawrence was the central figure, who came nearer than any others to keeping certain elements in earlier practice. Lawrence, by working on a white ground and using transparent paint freely, managed to give his work a brilliance and luminosity, which also mark the landscapes of Bonington and the genre painting of Wilkie, so that the *chic anglais*, as it was called, became the envy of continental painters. To some extent, too, the Pre-Raphaelite painters applied the principle of earlier methods, by using a ground of white lead and oil, with some copal varnish to harden it, and painting on this while it was still wet with

thin layers of colour, many of them transparent, so that light from the white ground was reflected through the colours and increased their brilliancy. Perhaps, however, the most successful of the adaptors was J. M. W. Turner. He was trained as a water-colour painter, and developed as an oil painter in conscious rivalry with the seventeenth-century Dutch painters and with Claude, using apparently similar methods to those they employed. About the middle of his life, the expression of light and atmosphere began to dominate his painting, and eventually became practically his main theme. For this, he virtually adapted to oil painting the technique of water-colour. The use of dark colours was severely restricted, and he used for the most part either transparent glazes or very thin layers of paint on a white ground, the reflection from which gave the luminosity he sought. Certainly knowledge of earlier technical methods made this adaptation possible, which other water-colour painters who turned to oil could not always achieve. Goya was an exception to the general rule. He has been called the last of the old masters and the first of the moderns, and technically as well as artistically he justifies the description. His earlier work, based on study of Velazquez, Rembrandt, and Tiepolo, reveals exploitation of the ground colour, and of combining layers of paint; his later work is handled much more directly. In his case, and probably in that of others, the abandonment of older methods may have been deliberate. The speed and liveliness of handling which direct painting could give perhaps seemed to answer better to nineteenth-century aims.

Direct painting gives rise to a number of troubles of its own, quite apart from those inherent in the use of oil. Even in the rare event of a painting being completed in one operation, so that the paint is of about the same consistency throughout, and is put down without serious changes or corrections, the surface when dry may have a horny, impoverished-looking quality. This can usually be corrected by a coat of varnish; but this, by altering the translucency of the medium holding the pigment, may change colour and tone. In other words, even in the most favourable circumstances, the painter can never be entirely certain how his work will ultimately look. It was

partly to overcome this difficulty that many nineteenth-century painters took to mixing other substances with oil for use as a medium. A mixture much used was *megilp*, which consisted of mastic dissolved in turpentine, with oil added. This yielded at first a brilliant, enamel-like effect; but quickly became dark and brittle, producing a network of deep cracks, sometimes squarish, sometimes irregular, which mar many nineteenth-century paintings.

Usually, however, in direct painting, there will be a whole series of modifications and corrections before the work is done, which introduces another set of difficulties. One of these is that with varying thicknesses of paint in different parts of a picture, each part is liable to dry with a different kind of surface—dull here, shiny there, or patchy elsewhere. Again, the final coat of varnish will restore unity of surface, but according to the different kinds of surface in the painting will affect their colour and tone in different degrees, and may upset the balance. Sometimes, therefore, painters have resorted to putting a transparent yellowish or greyish tone over the whole picture, which obscures divergences, and pulls the whole thing together. In time this tone is apt to darken, and the whole painting becomes darker. It is sometimes argued that this use of a tone is the equivalent of the older practice of glazing, ignoring the fact that the tone is meant to hide imperfections, while the glaze was used to amplify and to enrich. A more serious effect of additions and corrections is on the whole structure of the paint. Ideally, they should be made while the underlying paint is still wet, so that the new coat of paint becomes one with the underlying coat, almost as though they had been put on at the same time. In fact, this is rarely possible, and the next best thing, which the painter usually aims at, is for the underlying paint to be dry before more is added. As noted above, however, the paint may have dried with different kinds of surface in different parts, which are likely to affect in different ways the appearance of paint applied to them. So the painter takes steps to unify the surface on which he is going to paint by rubbing it over with whatever medium he may be using, with a thin layer of varnish (a preparation sold specially for this purpose is known as *retouching varnish*), or

sometimes even with white of egg. Often time did not allow the earlier painting to become properly dry. Particularly was this the case with fashionable portrait painters, who had fixed appointments with their clients. Here, in addition to inequalities in surface texture, some of the paint would still be 'tacky' and almost impossible to paint upon. Once more, therefore, resort was had to the use of medium or varnish both to unify the surface, and to enable the brush to move more easily over the tacky areas. The result of all this, especially if several paintings were involved, was to build up a kind of club sandwich of paint and other substances, in different stages of drying, and therefore contracting at different rates. Almost certainly, in course of time cracks would appear in the final coat, in number and size proportionate to the tensions at work beneath it.

Another source of trouble in nineteenth-century painting was the pigments used. Scientific discovery had made available many more of these than were known to earlier painters; but unfortunately, their limitations were not always realized, or if they were, how to guard against them was not known. An example is the aniline or coal-tar colours discovered by Perkin about the middle of the century. These presented a whole range of brilliant tints to the artist; but unfortunately they proved very fugitive and unsuitable for painters' use.

. . . . .

More interesting, however, than the difficulties and deficiencies of nineteenth-century painting methods, is the development of new techniques to achieve new aims, of which the most important was the increasingly ardent search to express light and atmosphere in landscape painting. It has been seen that Turner sought this goal by using oil glazes and scumbles in much the same way and on the same principles as the painter in transparent water-colour. Thereby he placed on himself similar limitations, and gave up some of the characteristics and powers of oil paint. John Constable explored other methods more in consonance with the possibilities of the medium, and thereby laid the foundations of much nineteenth-century practice.

Constable's belief that every part of a painting had to be thought

of in terms of light, led to a treatment of shadows in which these were regarded not merely as a negation of light, but as a variety of light. In other words, the shadowed side of an object or the shadow cast by an object had positive colours of their own. This was no new discovery. Great painters in the past, among them Titian, had realized it, and to a limited extent made use of it. Nor did Constable push the idea to its logical conclusion—that was left for others to do. But he was among the first to make it play a dominating and consistent part in his work. Constable also found that in every part of a painting, he could gain luminosity by 'breaking' his colour; that is, instead of painting a particular object (say) a uniform brown or green, he would introduce touches of various browns or greens or more vivid colours. The reason for this is that paint mixed on a palette to produce a particular colour often goes dead and muddy. If, however, the elements of the mixture are put side by side in small touches on the canvas, the colours reflected from each touch are fused by the eye, giving an appearance of one colour, but keeping a lively, luminous quality. Again, Constable found that by free brushwork with a considerable body of paint, he could make inequalities in the surface suggest the sparkle and gradation of light, an effect he reinforced by the free use of sharp flecks of solid white, often put in with a palette knife. To realize the extent of Constable's technical innovations, it is necessary to study his sketches, his large finished studies, and his later paintings, since in much of his earlier work painted for exhibition or for clients he subdued his natural inclinations to conform in some measure to the conventions of his day. But it was one of these exhibited pictures, *The Haywain* (now in the National Gallery, London), which, when shown in 1824 at the Salon in Paris, created a furore among French painters, and led the way to some of the major triumphs of French nineteenth-century painting.

Constable was not, of course, the first painter to use broken colour, and exploit the possibilities of impasto and of a palette knife; but he was the first painter to direct all such devices to the expression of light. In the hands of the French Impressionists, what he had begun was carried to a logical conclusion. It is now realized that Constable

in painting the skies which are a vital part of his landscapes, had made use of current scientific investigation into atmospheric phenomena.[1] Similarly, the Impressionists had behind them the researches of Helmholtz into the nature of light and colour. Whether, in fact, any of them had direct knowledge of Helmholtz's work is open to doubt. His ideas, however, were in the air, had received popular exposition, and so were accessible; and later Impressionist methods are a practical exposition of them. But it should be clearly understood that the earlier work of Manet, Monet, and other Impressionist leaders, was in direct descent from that of Velazquez, Goya, Corot, and Courbet. They were deeply interested in light and its expression, but it was not until the late sixties and the early seventies that they began to develop a special and characteristic technique. It was in the hands of Claude Monet (1840–1926), who was a true *chef d'école*, that this technique found its most complete development. Basic to his later practice were several ideas. One was, that it is what the eye sees, and not what the mind knows, that is of concern to the painter. Next, an object is visible only because light is reflected from it to the eye; in other words, in painting any part of an object or scene, the painter is concerned with light, and what we call darkness or shadow is only a particular kind of light. Again, as the scientists had discovered, white light is a combination of a whole range of differently coloured lights, composing what are known as the colours of the spectrum.[2] If any one of these types of light, or any combination of them, falls on an object, that light is not necessarily reflected to the eye. If none is reflected, the object is invisible; if some are reflected and others absorbed the object will appear the colour of the light or combination of lights that reaches the eye. Thus, the colour of an object as the eye sees it is dependent on two things; the character of

---

[1] See Kurt Badt, *John Constable's Clouds*, 1950.

[2] A more accurate way of stating this is that the sensation of light is due to a ray striking the eye. According to the particular ray or combination of rays concerned, the colour sensation will differ. The spectral rays range from ultra-violet to infra-red, through yellow, and when combined produce the sensation of white light. By themselves, ultra-violet and infra-red have no effect on the human eye, i.e. an object lit by an infra-red ray only would be invisible.

the light falling upon it, and the character of the object itself, which determines the light reflected from it. Lastly, the theory of complementary colours had become established. In its simplest form, this regarded the colours of the spectrum, which combined to make white light, as red, blue, and yellow; and the colour resulting from mixing any two of these together was called the complementary colour of the third, green, for example, being the complementary to red. If a spectator had been looking at one colour and then looked at a white surface, the complementary colour would appear; and if two colours were juxtaposed, there was a tendency for the complementary colour of each to appear in the other.

With this in mind, the Impressionist method of painting as typified by Monet is easily understood. First, the colours used were usually limited to a choice from those represented in the spectrum, blacks and browns being banished. This rule seems not, however, to have been rigidly observed, since black, for example, mixed with white can yield a delicate and useful blue. Secondly, every part of the painting was put in terms of definite colour. Take, for example, the treatment of shadows. In the case of the shadowed side of objects, the older practice had usually been to intensify the local colour, introducing a cool half-tone between light and shadow, and perhaps a reflected light in the shadow itself; while in cast shadows, what was called a 'shadow tone' of neutral grey or brown was used, into which local colour was either introduced, or allowed to break through from underlying paint. Roughly, this corresponded to what the eye sees; but the Impressionists made it more precise. Take a cast shadow in a landscape. The colour of this would be affected by three factors: (1) the colour of the surface on which it fell; (2) the colour of that surface in lit areas adjacent to the shadows, whose complementary colour would tend to appear in the shadows, especially at its edges; (3) the colour of the light reflected from the sky, or from surrounding objects. So came into existence the famous purple-blue shadows of Impressionist painting, in a landscape lit by yellow sunlight (purple is the complementary of yellow, and blue was reflected from the sky), and the strong blue shadows on snow under the orange light

of a setting sun. Again with the theory of colour in mind, the Impressionists were able to push the use of broken colour much further than Constable, who had worked only within a narrow range. They juxtaposed touches of more vivid colours, such as reds, blues, and yellows, to produce the appearance of a grey, or of yellow and blue to produce a green.

Too much must not be made of Impressionism as an application of scientific knowledge. The idea, for example, which has been put about that the Impressionists produced white by juxtaposing the spectral colours on their canvases, is quite ridiculous; such a combination would only give the impression of a dirty grey. The Impressionists, though they had scientific ideas in mind, applied them empirically rather than on a definite system. It was left for Georges Seurat (1859–91) to juxtapose equal-sized dots of different colours, these colours being determined beforehand according to the colour effect required, the number of dots of each colour being regulated according to the proportion of that colour needed. Naturally, the Impressionists had their difficulties. One of these was due to the fact that white paint, which was the top point in their colour range, is much less brilliant than white light. Consequently, if they pitched (as they did) their shadows to the key they found in nature, and took (as they were obliged) white as their highest light, the range of tone between the two was considerably smaller than in nature, and certain subtleties were lost, while the highest lights lost their effect. Constable, starting with darker shadows, could not only develop more variations in tone and colour, but could make his lights more effective by contrast.

Since Impressionist methods are based on colour analysis, they can only be fully grasped by study of original paintings. But from a monochrome reproduction of a detail of one of Monet's paintings of the façade of Rouen Cathedral (Pl. XXII) something can be seen of his use of broken colour, the texture of his paint, and the very narrow range of tone which his colour theories allowed him.

The influence of the Impressionist analysis upon modern painting has been profound. Cézanne, who rejected their aims, paid implicit

tribute to their work in the remark that he wanted to make of Impressionism something durable; and even on cubism and in modern abstract painting the impressionist palette and analysis of colour have had their influence.

. . . . .

The final stage in the making of an oil painting, whatever its date, was the application of a protective coating. As explained in Chapters 3 and 7, this might serve not only to protect the surface of a picture, but by changing the translucency of the pigment enrich the whole appearance of the painting, or where different areas had dried to different degrees of glossiness, bring the surface into unity. Judging from recipes and books of instructions, such a coating was intended always to be used, and it would be omitted only when it was likely to change the surface texture in a way the painter did not wish, as in the case of pictures painted with much turpentine in the medium to obtain a non-glossy effect. From the same sources, also, it appears that the protective coating was always either an oil or spirit varnish made with natural resins. Only quite recently have synthetic resins and wax come into use, and then more often among conservators than painters.[1] It should be realized that very rarely is a painting made before the nineteenth century seen carrying its original varnish only, since almost invariably this has been covered with one or more later coats. Sometimes, however, when these coats have been removed, what is probably the original varnish may be seen. From this, and from the fact that the additional coats are in most cases of the same types that were in use when the picture was painted, it may be deduced that original varnishes have generally darkened, yellowed, or disintegrated to an extent determined by their composition. Broadly speaking, oil varnishes darken and yellow, and become tougher, taking on a horny appearance; spirit varnishes also yellow, but crack and splinter far more readily, since they are not only apt to be made from softer resins, but lack the protection of an oil film. Spirit varnishes, however, can easily be removed, while oil varnishes

---

[1] It has been claimed that a coat of linseed oil, treated to retard its yellowing, is a satisfactory protective layer. But there seems to be no historic precedent for its use.

may become so hard that removal without damaging the underlying paint may be difficult.[1]

Clearly, in studying a painting, the effect on its appearance of whatever may have happened to the protective varnish must be taken into account, though it may be emphasized that the varnish which is visible may not be that applied by the painter. The student should also be prepared sometimes to see a painting that has never been varnished at all. As a rule this only happens with nineteenth- or twentieth-century paintings. Sometimes, as noted above, it is deliberate, in the interests of surface quality. Sometimes it is pure forgetfulness. More often it is due to a painting having been sold before the need for any varnish became apparent, or before it was judged safe to apply varnish, since varnish on paint that is not sufficiently dry may cause cracking. Sometimes, also, a painting has been given a temporary varnish for exhibition purposes, and has been sold before this was replaced by something more permanent. On what were known as 'varnishing days' before the opening of such exhibitions as those of the French Salon and the Royal Academy, painters sometimes used to apply a coat of white of egg or of shellac, both of which quickly disintegrate, and easily fall from the surface. Incidentally, if a resinous varnish were applied over one of these temporary coverings before they had disintegrated, their cracking and splintering under the varnish could give trouble.

Probably, earlier painters acted in much the same way as later ones are known to have done. There is, for example, some evidence of white of egg being used as a varnish, temporary or otherwise, in the eighteenth century. But by this time, later hands have concealed the results of their behaviour.

---

[1] On this point, on the appearance of disintegrating varnish, and on its treatment, something is said in a later chapter on Restoration.

# 8

## PRELIMINARIES TO MAKING
## A PAINTING

In the foregoing chapters something has been said about what has
to be done as a preliminary to making a painting, notably in the case
of fresco and tempera. Here, this work is described in somewhat
greater detail, with special reference to oil painting.

A question that is often asked is how an elaborate composition
which includes many figures was brought into being. Obviously, it
could rarely have been done by finding or constructing a suitable
setting, arranging the figures together in a studio or in the open air,
and making a painting directly from the group. Ordinarily, therefore,
the artist began by preparing a sketch of the whole composition he
had in mind. For this, widely different materials were used, including
chalk, pencil, pen and ink, water-colour, and oil. Probably not one
but a whole series of sketches would be made, with differences in
the placing of the main masses, in the grouping of the figures, in
their attitudes and movements, in their relation to one another and
to the setting, and so on. In these sketches was adumbrated not only
the formal character of the composition, but what may be called its
dramatic core. For their making, the artist relied mainly upon
memory, and made little or no reference to nature; but it is known
that sometimes artists used various devices to stimulate imagination.
Thus, Tintoretto is said by Ridolfi (in his life of Tintoretto, first
published 1642) to have made small figures which he could arrange
under different systems of lighting, not only to suggest the position
of the figures, but the whole system of light and shade in the painting.

It must be remembered, however, that the artist was not always free to choose either the subject or the method of interpretation.[1] Probably, before the nineteenth century, the majority of subjects were chosen by or to suit a particular client; in the nineteenth and twentieth centuries the balance has been the other way. Only when the artist had not only chosen the subject, but painted it for himself alone, was his freedom complete. Otherwise, even with a subject of his own choosing, he would be likely to paint with his eye on a potential market and pay some regard to the conventions of the day; while with the subject determined in some other way, even in the rare event of the artist being allowed to work it out as he thought fit, these conventions, a client's wishes, or a mixture of both would affect him. Recently much attention has been paid to the *raison d'être* of subject-matter, why it was treated on certain lines, and the meaning of its details; a study formerly known as iconography, but in the more systematic form it has now taken sometimes called iconology.[2] It is not possible here to consider the matter at any length; but some of the factors to be taken into account may be mentioned. Broadly, religious pictures are intended to instruct, to edify, or to warn; but the subjects used for these purposes vary considerably with place and period quite apart from any wishes of the client. For example, themes were not necessarily chosen from the Bible as we know it today. The Middle Ages made use of all kinds of religious writings now regarded as apocryphal, a famous example being some of the scenes concerned with Joachim and Anna painted by Giotto in the Arena Chapel at Padua; while the great medieval encyclopaedias, incorporating most of the learning of the time, both sacred and profane, supplied much material.[3] Later, these sources for subjects were virtually given up in religious painting; but various compilations of the

---

[1] This word is used in preference to treatment, to avoid confusion with technical handling.

[2] Cf. Panofsky, *Studies in Iconology*, 1939; and the *Journal of the Warburg and Courtauld Institutes, passim.*

[3] Cf. Émile Mâle, *L'Art religieux du XII^{ème} siècle en France*, Paris, 1924, and the two companion volumes dealing with the thirteenth century and the end of the Middle Ages.

Lives of the Saints have been constantly in use. Local circumstances also played their part. Subjects connected with the Virgin play a particularly important part in the art of Siena, which city was dedicated to her; in medieval Umbria, representations of St. Francis and of episodes in his life were frequent; in Venice, where the cult of St. Catherine of Alexandria was strong, especially in the sixteenth century, that saint and her legend were a favourite theme for painters; and in seventeenth-century Spain, the widespread teaching of the doctrine of the Immaculate Conception bred many paintings of that subject. Very marked, too, was the increased use of certain types of subject after the Council of Trent and the revival of the great teaching orders. Incidents taken from the history of the orders and from the lives of their leading figures appear more often than ever before, together with those likely to stimulate personal mystical devotion. Contemporary with this, in northern countries where the ideas of the Reformation prevailed, subjects were taken almost wholly from the Bible, with emphasis on those in which the personal and human character was uppermost. Similar considerations help to explain the presence of particular persons, religious and otherwise, in religious paintings. Saints might be the patrons of the city, church, or institution for which the picture was painted, or may have had the altar dedicated to them for which the painting is designed; sometimes they were patrons of the donor, whether an individual or a corporate body, portraits of whom might also be introduced.

When it came to the interpretation of a chosen theme, especially in religious paintings, the rules both of the Church and of custom played an equally important part. Saints had to be identified by wearing appropriate robes and accessories, and by holding or having near them emblems, which either symbolized their achievements or the form of their martyrdom. Usually, it is not difficult to recognize who is represented. Sometimes, however, when there is no emblem or it is one used for several different saints, much exercise of learning may be required, especially if the painting is an isolated panel separated from companions which might afford a clue. Again, the colours

used had to be those recognized as proper to the saint represented, the Virgin, for example, almost invariably being clad in blue. It is important to remember, also, that in religious painting the interpretation may be historical or symbolic or a mixture of the two. For example, paintings of the Crucifixion range from those in which every detail can be accounted for by a passage in one of the Bible narratives, to those in which the Crucified Christ is surrounded by the figures of those who not only took no part in the event, but may have lived hundreds of years later. So it is with many other subjects; and it is often very difficult to account for any particular interpretation. Certainly, this had to conform to the doctrines of the religious body concerned; but these again varied from place to place, and from time to time. Frequently, the teaching or writings of some great man, such as St. Bonaventura, would find reflection in the treatment of certain subjects; while sometimes a whole series of pictures can only be explained as due to some particular religious event. Again in the Middle Ages, conventions sanctioned by the Church largely ruled. In such and such a scene, such and such persons must appear, each cast for a definite role. Yet these conventions could differ in the same period. Duccio, painting scenes from the life of the Virgin and Christ in his famous *Majesty of the Virgin* at Siena, largely based his designs on Byzantine tradition; while a contemporary illuminator of manuscripts in northern Europe would for the same subjects follow different rules. Even in later ages, when the artist had far more freedom, the Church intervened; and in the late sixteenth and the seventeenth centuries there were strict regulations regarding the treatment of the nude in religious painting. Local temperament also had its influence. Flemish fifteenth-century approach to any particular subject is likely to be more literal than the approach of an Italian, even where it is as packed with symbolism as the famous *Adoration of the Lamb* by Van Eyck, in Ghent.

In secular subjects, similar determinants of subject and treatment operated, but had different weight. In subject, place and period were both important. The heroes, exploits, and usages of medieval chivalry, for example, were much more likely to occupy a northern painter

than an Italian, who found them chiefly useful for such purposes as the panels used to decorate *cassoni* (chests). In contrast the heroes and stories of classical antiquity which in fifteenth and sixteenth century Italy formed the staple of non-religious painting, only became acclimatized considerably later in the north. Comparing different periods, historical and philosophic themes became more common during and after the Renaissance and Reformation, to some extent replacing episodes from the Bible and doctrinal expositions. Portrait painting, also, is largely a creation of the same period. Genre painting is not widely practised until the seventeenth century, its main centre being in the Netherlands until the eighteenth century. Still-life painting, likewise, is rare until the seventeenth century, and since then has always found its principal home in the north. Landscape painting, again, is largely a creation of the seventeenth century, and finds its fullest development in nineteenth-century France. Within these broad categories of time and place, choice of subject rested mainly with the client, whether an individual or a corporate body. In work done for societies and public bodies, certain standard and recognizable themes might have to be selected, and social conventions and aspirations played their part; but there were fewer limitations on choice than in the case of religious painting.

Interpretation, also, was largely a matter between artist and client. There were no necessary rules as to doctrinal correctness to be observed, nor, broadly speaking, of propriety. But at the same time the painter was often very strictly controlled by the client as to how the subject was to be interpreted, and what details were to be introduced. Sometimes the artist would propose a way of treating the subject, which would be submitted to the client and hammered out between the two; not infrequently, especially in the sixteenth century in Italy, elaborate programmes would be drawn up by scholars, full of the most esoteric learning of the time, which the artist was expected to carry out in detail. A well-known example is the series of paintings made for the Grotta of Isabella d'Este in the Castle of Mantua, by such distinguished artists as Mantegna, Lorenzo Costa, and Perugino, concerning which she wrote to Perugino, 'You are not to add

anything of your own.'[1] In the same way portraits, especially in early periods, are often full of accessories which have a carefully worked out relation to the sitter, and are not merely decorative details introduced at random. A famous and very early case is the portrait group of Jan Arnolfini and his wife by Jan van Eyck;[2] and notable examples are among portraits by Holbein. In fact until the nineteenth century it is never safe to assume that any subject or the way it has been developed is a matter of the arbitrary taste of the painter. At the same time modern scholars are sometimes inclined to elaborate over much the sources from which earlier painters derived their material, tracing details in a painting back to a wide range of learned authorities. This may be justified when it is known that a programme was prepared by some outside authority; but ordinarily painters have neither time nor equipment for elaborate literary research, and the explanation of why a subject is treated in a particular way must be sought in some textbook or manual current in the painter's time, of which the names are almost forgotten, and copies difficult to secure.[3]

This account of the choice and interpretation of a subject is very slight; but it may give some idea of the factors involved, and the important part they may have played (and may still play) in the making of a painting. Assuming, however, subject and interpretation had been settled, and embodied in a sketch of the whole design, the next stage was to elaborate this by a series of drawings and studies for different parts. For this, models both nude and clothed might be employed, both for single figures and for groups; though in the case of some painters, such as Rubens, their knowledge of the human figure was such that models were not always necessary. Studies would probably be made of drapery, of different accessories, and of architecture and landscape where these were involved as settings or backgrounds. The widest variety of materials might be used, and the studies range from a slight indication to an elaborate finished

---

[1] Cf. Wind, *Bellini's Feast of the Gods*, Cambridge, Mass., 1948.
[2] Panofsky, *Burlington Magazine*, March 1934.
[3] Cf. Seznec, *La Survivance des dieux antiques*, London, 1940, Book II.

painting.[1] Drawings and studies were not, however, always made *ad hoc*, sometimes material already in existence being adapted, or first ideas modified to permit their being used.

The preliminary sketch of the design, and the drawings and studies, might then be combined to produce a comparatively highly finished small version of the intended painting, sometimes called a *modello* (though this term has been used, somewhat pretentiously, for the preliminary sketch); or in the case of large paintings especially those intended for mural decoration a cartoon would be prepared, of the same size as the proposed work. In either case, assistants might be employed; and in any event both preliminary sketch and studies might be considerably modified, to bring everything into unity. Whether a modello or cartoon was made at all, however, depended on circumstances. In fresco, as explained in Chapter 5, the painter in early days seems to have relied on preliminary drawings alone, though later a cartoon seems to have been invariably used, which was prepared from preliminary drawings by squaring up (see below). In tempera, cases are known of a detailed drawing being made of the same size as the painting, which was broadly the equivalent of a cartoon. Frequently, however, both in tempera and oil, there is no evidence of a modello having been made at all, work on the painting apparently being based on the preliminary sketch and the detailed studies. But it is well to be cautious over this since small versions exist of a considerable number of paintings, at best only in part by the master, which it is customary to regard as made from the painting, but which may conceivably be preparatory versions made by assistants and worked on by the master.

The next stage would be to get the finished design on to the surface prepared to receive it. How this was done in the case of fresco, by pouncing or tracing with a stylus from the cartoon, has already been explained. In tempera, if a drawing the same size as the proposed painting had been made, this might also be pounced on to the gesso ground, as a basis for the drawing to be made on the gesso.

[1] Examples can be found of all types in any of the larger collections of drawings. A convenient and authoritative selection is in Meder, *Die Handzeichnung*, Vienna, 1919.

In oil painting the usual process was (and is) squaring up. The pre-
liminary sketch or modello would be divided into squares; the surface
for the painting would be divided into the same number of squares;
and the design could then be drawn in section by section, work in
which assistants would be largely employed.[1] Once the design was
on the prepared surface, work would proceed according to the
method of painting adopted; though in this last stage there would be
constant reference to the preparatory drawings and studies, and re-
course might again be had to models or to other material, either for
making further studies or for direct work on the painting.

At some stage, perhaps a perspective diagram would be made to
help in putting the different parts of the painting in scale with each
other.[2] It is often thought that linear perspective is primarily a means
of helping to simulate the appearance of a scene. This it does to the
extent of putting into geometrical terms certain facts of vision, e.g.
that parallel lines, such as the edges of a road, receding from the
spectator appear to approach each other in the distance; though it
also ignores other similar facts, e.g. that the edges of a tall building
seen from the ground look nearer together at the top than at the
bottom. In fact, perspective from the painter's standpoint is best re-
garded as a means of organizing the relations in space of the different
elements in his painting, so that they appear to form a consistent and
coherent whole, which corresponds to some of the facts of vision.[3]
That many artists so treated it is indicated by their sometimes
deliberately disregarding the logical working-out of the perspective
system they were using. Paolo Veronese would on occasion construct
his perspective scaffolding as though the spectator were looking at

---

[1] Modern painters have occasionally used modern inventions to save the time and
labour this involves. One of these is to prepare a lantern-slide of the sketch, throw it on
the painting surface, and draw around the image.

[2] The first formulation of the basic rules of linear perspective as it is used today was
made by Leon Battista Alberti, the Florentine architect and writer, in a book written
1435–6. Concerning this, and for an illuminating analysis of what perspective does for
the artist, see W. M. Ivins, *On the Rationalization of Sight*, New York, 1938.

[3] Some systems of perspective, notably those used in the great ages of Far Eastern
painting, disregard these facts to a greater extent than that customarily used in the West.

the scene from several points of view, and Canaletto would make parallel lines converge in a quite arbitrary way.

The above description applies mainly to more or less elaborate figure compositions. Even so, it must not be taken as always applicable to any particular case. Though we have plenty of material probably connected with the preparatory stages in making a painting, we cannot always be sure how it was used. Sometimes it is difficult even to guess whether the sketch of a composition was the result of a series of drawings, or vice versa; and at what stage a particular drawing or study was made and used is often doubtful, though sometimes oil marks on drawings suggest that they were used during the painting of the picture. Also, there is good reason to think that some painters, among them Hals and Velazquez, omitted much of the preliminary work, since sketches and drawings by them are either unknown or very rare.[1] Yet it is well to be cautious. Inevitably, many sketches and drawings, once they had served their purpose, were destroyed either by the painter himself, or shortly after his death.[2] Since preliminary sketches by the great Venetians were at one time unknown, it was thought they did not make them; but recently evidence has emerged that such sketches do exist in certain cases.[3]

In still-life, portrait, and landscape painting, though the preliminaries were similar in character, they received a different emphasis. In the nineteenth century the tendency was to omit them altogether, and work direct on the canvas in the presence of the subject. In the case of still-life, when the objects in the group were not perishable, this may have been the practice in earlier days also. The puzzle is how did the painter proceed with the elaborate bouquets of flowers, and the vast conglomerations of fish, flesh, vegetables, and fruit, which were such favourite subjects with the Dutch and Flemish. Painted as

[1] Recent examination by X-ray of the Caravaggio paintings in S. Luigi dei Francesi in Rome has revealed that in some cases the painting as seen conceals a widely differing design, suggesting (contrary to expectation) that preliminary sketches were little used.

[2] The recent destruction by Georges Rouault of much that had accumulated in his studio, is unlikely to be a unique case.

[3] See Frölich-Bum, *Burlington Magazine*, June 1948, p. 169.

they are with great elaboration, it is inconceivable that the group was first arranged, and the painter worked from it. A reasonable hypothesis is that a sketch of the whole group was made, then detailed studies of individual objects, which were then fitted together according to plan; but unfortunately, evidence is lacking.[1] In portrait painting, means had to be found to save the sitters' time, especially when they were people of importance. In the sixteenth century one method was to make a careful drawing from which the painting was made, probably without any further reference to the sitter; and this probably explains why the drawings of the English court circle in the matchless series by Holbein often have more 'bite' and expression of character than his paintings of the same people. In the same century, in Italy, however, the preference seems to have been either for working direct on the canvas, or making a painting of the head alone as a preliminary; and this continued to be the practice in the seventeenth and eighteenth centuries. In a portrait group in the National Portrait Gallery, London, painted in 1777, by J. F. Rigaud, Carlini is represented painting from a sitter directly on to the canvas, with a chalk outline to serve as a guide. Bartolozzi (standing) and Cipriani are at his side (Pl. XXIII). Many portrait drawings were made, but more often as ends in themselves than as preparation for a painting, though examples of preparatory drawings are known. Sometimes, also, preliminary sketches were made suggesting the pose of the sitter, the general design, and the colour. With a painting or drawing of the head and with such sketches, the finished painting would be made by using a model wearing the appropriate clothes, or draping these on a lay-figure. In the nineteenth century similar methods were used, but increasingly the practice developed of beginning work direct on the canvas, and of painting only when the sitter was present.

Though not always confined to the preparatory stages of painting,

[1] Cézanne, a slow worker, is said to have got over the difficulty of flowers dying by using artificial ones. Another nineteenth-century device was to keep substituting new flowers. For fish and flesh, however, it would be difficult to find substitutes reasonably similar, and would be costly.

the use of mirrors may be conveniently mentioned here. Every portrait painter at some time paints his own portrait, usually more than once, and for so doing uses a mirror. This, of course, reverses everything, and care has to be taken if the painter is right-handed that he is not represented as left-handed, and vice versa, while the hand holding the brush may have to be painted from memory, or by adaptation from the free hand. It has therefore been suggested that sometimes a second mirror may have been used to overcome this difficulty. Possibly, in the famous *Artist in his Studio* by Vermeer (frontispiece), some such arrangement may have been contrived as that used by tailors to enable a customer to see his own back. Incidentally, it is not always easy, in the case of an artist whose features are not known, to tell a self-portrait from a portrait of another painter. The arrangement of the hands is usually the best clue, since in the case of a self-portrait this will be such that the hand holding the brush will always be free. Undoubtedly the most remarkable painting for which a mirror was most probably used is *Las Meniñas* by Velazquez, in the Prado (Pl. XXIV). Here Velazquez had to face the problem of his sitters being in the foreground, while he himself, standing at his easel, is behind them. He could, of course, have painted everything in the picture except himself, and then put himself in from a study. This, however, would have involved difficulties, notably those of tone; and he therefore appears to have reflected the whole scene, including himself, in a mirror.

In landscape, there was a similar use of drawings to that in figure painting, and the same tendency in the nineteenth century to paint direct from the subject. Before the nineteenth century, to make a painting 'on the ground' was most exceptional. Claude roamed the Roman Campagna making drawings, mainly in pen and ink; and it was from these, coupled with memory, that his paintings were made. Canaletto, and the whole race of topographical draughtsmen, worked in a similar way. We can trace the progress of a Canaletto painting from a slight pen-and-ink sketch made on the ground, through increasingly elaborated drawings apparently made, at least in part, in the studio, to the final painting also produced there. Even Con-

stable, with his passion for seizing swiftly changing effects of light, relied upon oil sketches made in front of the subject as material for his large pictures, painted mainly in the studio. Painters before his time did not go as a rule even as far as this, for landscape sketches in colour, preparatory to a larger painting, are rare. It has to be remembered that the earlier painters of landscape were not much concerned with representing a particular view as it appeared to the eye, but sought rather to express general character and sentiment. Thus a great many landscapes were painted which, while recalling some particular place or region or even introducing recognizable features, were virtually imaginary. Even the topographers, tied as they were to painting specific facts, put these into more or less conventional terms and standardized the treatment of light; while many of them varied their production by painting *capricci*, imaginary collocations of known buildings or groups of imaginary buildings, which were particularly popular in the eighteenth century. The argument was (and is maintained by some modern landscape painters) that to work in front of nature all the time is disturbing, since there are not only constant changes in light, but accidents rather than essentials are apt to attract the painter's attention. Consequently, during the nineteenth century, many landscapes were painted on the basis of sketches and drawings, allied to memory. The Impressionists held that working out of doors in front of the subject was essential, and under their influence, for a time this became the rule throughout Europe. But in the twentieth century there has come a reversion to earlier practice. Even Monet in his later years recognized the force of the objections to working altogether out of doors; and sought to meet these by keeping going a series of paintings of the same subject, working on each canvas only when conditions of light were those that he intended in that particular case.

In the business of making drawings and sketches for a painting, and especially in landscape, many different devices were used, which are occasionally referred to in books and catalogues. One practice was to construct a rough model of a scene to be painted, less as something to be copied than as a means of studying composition and light and

shade; and just as Tintoretto used small figures as an aid to design, so Gainsborough is recorded to have built up from stones, moss, and twigs, suggestions for drawing or painting landscape. Much more regularly in use among landscape painters from the seventeenth century onward was the Claude glass and the camera obscura, which have been described in Chapter 2 as part of an artist's equipment, while in the nineteenth century the camera lucida, an improved version of the camera obscura, was occasionally used. These were all means to put any given scene within a small area, so that its suitability as a composition could be studied, and to facilitate making a drawing of it. Another device, not restricted to landscape painters, but used in all kinds of work, was to look at an object or scene through a frame divided into squares by strings, and paint or draw upon a surface similarly divided.[1] An analogous apparatus, known to Leonardo da Vinci and Dürer, was the so-called *tracing machine*, in which the object was looked at through a glass and the visual image traced on it. Needless to say, in modern times, artists have also made use of photography to supply them with the equivalent of sketches and studies of detail; while occasionally photographic means have been used to transfer a complete sketch or even a photograph itself to a surface prepared for painting.

Before beginning to paint the artist had to *set his palette*. This had two stages: choice of colours to be used, and their arrangement on the palette. Broadly speaking, in both respects this was a more systematic and standardized affair than it became in the nineteenth century and later, reflecting more systematic and standardized methods of painting, less subject to individual caprice, and to the call to imitate what was before the painters' eyes. The chief sources of information are manuals of instruction and portraits or self-portraits of painters with their palettes.[2] Up to the end of the sixteenth century such sources are comparatively rare. From Cennino Cennini,

---

[1] One modern Italian painter looking at his subject through such a framework, used to divide his canvas into the same number of squares by threads. These he sometimes did not trouble to remove, and they can be found occasionally embedded in the paint.

[2] An example is reproduced on Pl. XXIII.

however, the practice of tempera painters in his day can be learned, which probably held good until painting in tempera was displaced by the use of oil. The number of different pigments used by him was small, and there is no indication of how they were grouped for use; but one important principle emerges—that of preparing ahead of time the tints for the shadows, the half-tones, and the lights of whatever was being painted, and of not waiting to mix them until the moment of painting. Concerning sixteenth-century practice, when oil had come generally into use, both written and pictorial information exists for the Swiss painters of the generation following Holbein.[1] From this it appears that the number of pigments used was small, that they were arranged on the palette with white on the right (nearest the thumb-hole), and with black on the extreme left, and that a flesh tint was ready mixed and placed under the row of colours. In the seventeenth and eighteenth centuries, however, both books of instruction and portraits of artists became much more common, and it is easier to discover exactly what was done.[2] Both in choice of colours and their disposition on the palette, there were notable differences among painters. But these were mainly variations made to suit the particular methods and purposes of the artist, on a set of principles widely accepted and practised. First was laid out a row of colours regarded as principal or basic, especially so in the earlier stages of painting. Corneille gives these as eight, and most painters of the eighteenth century used about this number. They were mainly earth colours, and included white, black, yellow, red umber, and green (*terre verte*), white being on the right near the thumb-hole of the palette, followed by the yellows, reds, greens, browns, with black on the extreme left. One variation on this, made by Chardin, was to put the yellows below the other colours; another, by Boucher, was to omit black. The position of white was due to its being more frequently used, mainly

[1] See Schmid, *The Practice of Painting*, London, n.d., concerning this, and also for much information on palette arrangement. See also Pl. I.

[2] Among instruction books which give information and were widely used are J.-B. Corneille, *Les Premiers Elements de la peinture pratique*, Paris, 1684, which gives French practice; and Thomas Bardwell, *The Practice of Painting and Perspective Made Easy*, London, 1756, which relates to England.

in mixtures, than other colours. This meant that it had to be more accessible and that more had to be put out on the palette, the greater weight being conveniently supported by the thumb. Subsidiary colours were then placed as the painter wished, sometimes below the others, sometimes introduced into the first line, sometimes forming a continuation of that line. Next, a variety of *tints* (as they were called) were mixed up, some for lights, some for half-tones, some for shadows. Despite some differences in the colours used, these mixtures yielded a more or less standard set of tints, both cool and warm in each of the groups. Corneille, for example, recommends for flesh painting four different tints for lights, three for half-tones, two for shadows; Bardwell gives for flesh painting twelve tints, which include what he calls shade-tint, red-shade, warm-shade and dark-shade, and gives a separate though similar set for landscape. The important point is that these tints were prepared before the painter began to paint, and were laid ready on the palette below the rows of separate colours. But despite these formalized methods, considerable elasticity was possible. Apart from variations in colour choice, the type and number of tints prepared would be selected according to what was to be painted. Moreover, all the colours and all the tints it had been decided to use were not necessarily all laid out on the palette at once. Those required for the first lay-in might first be put ready, and the painting carried to a certain stage, then those required for scumbling and glazing and finishing might be added. Bardwell in particular gives definite instructions as to this, notably when a portrait was to be painted.

This description of setting a palette may seem over-long, but it emphasizes how much more orderly painting procedures were in the past than they were apt to be in the nineteenth century. Wonder is often expressed at the immense amount of work on a high level earlier painters were able to turn out. At least a partial explanation is that preparations for painting were more systematic and carefully considered than they came to be later, and so the actual making of the painting could be carried out with remarkable speed. It is of some interest, therefore, to know that in modern times there has

been an attempt to introduce the use of what is called a *scaled palette*. The basis of this is that before beginning to paint, a limited number of colours (including black and white) are selected according to what is to be painted. From these, by mixing on definite principles, sequences of various colours can be made, ranging in hue and intensity from black to white, which are then put on the palette in order.[1] This, like older practice, avoids random mixing on the palette, and systematizes work; and by taking into account modern discoveries concerning colour, has adjusted the palette to some of the needs of representational painting.

[1] See Denman W. Ross, *The Painter's Palette*, Boston, 1929; and Arthur Pope, *Introduction to the Language of Drawing and Painting*, vol. i, Cambridge, Mass., 1929.

# 9

## THE RESTORER'S CONTRIBUTION

ONE of the most difficult things to judge is how far a painting comes within reasonable distance of looking as it did when just painted. In time even the most soundly constructed work will deteriorate in some way, and frequently other hands than those of its maker have made changes and additions. Generally, the purpose of these has been to conceal damages or deterioration, or to attempt to repair them; but in many cases they have been designed to fit a painting to the taste of an owner or of a period. Nude figures have had drapery painted over them (a famous case is that of Michelangelo's *Last Judgment* in the Sistine Chapel); the colour of an ancestor's coat has been changed because a descendant was tired of it; additional figures have been added to groups; saints who have gone out of fashion have been transformed into others; the sacristan of a church has freshened up the draperies of a painting in preparation for a festival; and sometimes even a son has had the portrait of his father adapted to represent himself with a gold chain added to increase his importance. All this, of course, is quite apart from deliberate falsification to make the worse appear the better (or rather the more valuable) picture, by such means as transforming a school piece into what purports to be the work of a master, or changing an eighteenth-century painting by an obscure English painter into the portrait of a colonial worthy, adding an inscription and a date.

It is on account of all such changes, whether accidental or deliberate, that the services are needed of a restorer, or as he is more usually called today, a conservator. The change in title is significant; the aim today is to retard deterioration as much as possible by dealing

with its causes, both in the painting itself and in its environment, rather than to wait until it occurs and then take measures. But with a large inheritance of troubles whose seeds were sown in the past, and the constant liability of something going wrong with a painting, even under the best conditions, the conservator has always to be ready to apply treatment more or less drastic. Since both the disease and the remedy may influence the appearance of the painting and are likely to affect its structure, while they are sometimes mentioned in books and catalogues, the student should know something about them. There follows, therefore, a brief description of the chief ills to which paintings are subject, and how they have been treated; an explanation of terms and not a treatise on conservation.[1]

Every element in a painting is subject to some characteristic form of trouble, and unfortunately those which occur in underlying layers are liable to affect those above them. Take the support first. Wood has weaknesses of its own, of which something has been said, chief among them being a tendency to split and to warp. In the case of a split, the ground and paint may also be split, and fragments of them be detached at the edges of the break. Warping is apt to detach the ground from the wood in places, causing it and the paint to lift and form what are called *blisters*. Sometimes, if the warping is considerable, or goes on for some time, these blisters may break, and fragments of ground and paint become detached, leaving *holes*. Another hazard to which wood is liable is the growth of fungi, which may cause the wood to rot and crumble. More common in the case of paintings are attacks by worms (properly the larvae of beetles), which tunnel in the wood and may reduce it to a mere shell, enclosing a kind of irregular honeycomb of desiccated wood. Often, there is no sign of worm holes on the paint surface; but occasionally they occur in both ground and paint. The presence of worms in a panel is sometimes indicated by traces of sawdust at the lower edge of a painting, caught by the edge of the frame; though this may be old sawdust shaken out of the panel in which worms are no longer active.

---

[1] For those who want to pursue the matter, an authoritative book is that of George L. Stout, *The Care of Pictures*, New York, 1948.

Sometimes, as the result of a support being thus weakened, the ground and paint may collapse, breaking the surface. Sometimes again, the expansion of air within the holes in the support will lift the ground and paint, and so cause blistering. Yet another possible source of trouble in wood is the presence of resins, which soak into the ground and discolour it so that in turn the colour of the paint is affected, and it appears blotchy.

The remedies applied vary with the disease. A split may be repaired by simply glueing its edges together. Sometimes it may be further secured by glueing small pieces of wood across it (sometimes called *buttons*); or these may be inset and glued into place (then sometimes called *dowels* or *keys*). On occasion a piece of wood may be found glued along the whole length of a split, either on the surface or inset; and sometimes, after the split has been brought together, the original panel has been glued to one of the same size. In the case of warping, battens may also be glued or screwed to the back of a panel, or inset, but a more elaborate and much used method is to apply a *cradle*. This consists of a number of wooden slats glued to the back of the panel in the same direction as the grain. In each slat is cut a number of slots, so that transverse slats can be put through them which are movable and, of course, run across the grain of the wood. The theory is that the transverse slats keep the panel flat, but being movable enable it to expand and contract within limits.

When a panel has been attacked by worm, and the worm appears still to be active, it is generally treated either with liquid or gas to kill the worm. If this succeeds, and damage has not gone too far, nothing more may be needed. Often, however, as the result either of worm or some type of rot, a panel has disintegrated so much that some kind of strengthening is needed. A modern treatment is to fill all holes that are accessible with wax, the purpose being to support what remains of the wood. The wax, being inert, will not contract or expand; and so will put no strain on the panel. More usually, however, such wood is removed as is necessary to get rid of the damaged parts, and the thinned panel may then be *cored*, i.e. a piece of wood of the same size is glued to it with the grain running at

right angles, on top of which is added another piece with the grain running the same way as that of the original panel. The principle here is that of three-ply wood, and the aim is to prevent warping. If enough of the original panel is left it may be cradled; and sometimes a cored panel is cradled as an additional precaution.

In extreme cases of splitting, warping, and decay the ground and paint film are *transferred* to another panel or to canvas. This operation, which seems to laymen near a miracle, is simple in theory though it needs great skill in practice. After the face of the painting has been covered to protect it (usually with layers of tissue paper secured with wax or paste) the panel is gradually removed from the back until the gesso is exposed. The new panel or canvas is then fastened to this by a suitable adhesive (wax or size are examples), and the protective covering of the surface then removed. It is because it has been transferred that a painting whose surface has the smoothness and close-knit texture of a painting on wood, is sometimes found to be on canvas. This same process of transfer is used in the case of frescoes which are disintegrating because their support (the wall and plaster) is defective, or which are in a building that is being pulled down. After the front of the fresco has been protected, it is removed together with the plaster and part of the wall. In the case of a large painting this has to be done in sections. The part of the wall and any broken or decayed plaster is then removed, and the painting mounted, generally on canvas.

Supports other than wood have weaknesses of their own. Paper and cardboard are both normally fragile, and so are sometimes mounted upon wood, to whose vagaries they may then become liable; while they often contain substances which cause them to become brittle, and to change colour.[1] Also, the size that they contain, as well as the size or gum sometimes used as mediums in painting upon them, are good harbourage for various kinds of fungus, which reveal themselves in the form of yellow and brown markings, known as *foxing*. Discoloration due to the support, especially in the case of transparent water-colour, will immediately affect the appearance of the painting,

[1] An old newspaper or cheap book illustrates the possibilities.

darkening it or producing disagreeable blotches. This can in most cases be effectually treated by using solutions or gases, which bleach the support without affecting the paint. In the case of foxing, materials are also available which kill the fungus growths. In both cases, however, care has to be taken not to weaken the support unduly through chemical action. Disintegration is more difficult to treat, but in skilled hands, since paper and card are composed of a series of layers, they can be thinned from the back, and the painting given virtually a new support. Those who can split a five-pound note can obviously achieve near miracles in the case of a painting. Often, however, the source of trouble in paintings on paper or card is not the support, but the material on which they are mounted. Watercolours, especially, were often put on mounts which contained harmful substances, sometimes with a paste which attracts damp, is a breeding ground for fungi, and sometimes contains preservatives that have affected the paint. In such cases the restorer removes the mount or, if this for some reason cannot be done, treats it as he would a defective support.

Deterioration in the case of canvas, apart from that caused by thrusting broom handles or similar implements through it, can often be traced to its being of poor quality, irregularly woven and largely held together by size. This means that, as the size loses its holding and protective power, the canvas disintegrates, loosening the ground and paint. Even when it is new, however, the expansion and contraction caused by atmospheric changes are, owing to the irregular weave, apt to be different in different parts of the canvas, and by the irregularity of the pull loosen the ground and paint in places. Moreover, the excess of size in the canvas provides a breeding-place for fungus, which may discolour the ground and affect the paint. Even when a canvas is of good quality, however, and therefore lasts longer, and is of more even texture, if it is nailed to the stretcher in such a way that the pulls upon it are uneven, there may be disastrous results to ground and paint. Frequently, too, a canvas has been too tightly stretched, so that friction between it and the edge of the stretcher causes it to split. When the canvas is of reasonably good

quality and in good condition, restretching combined with patching of any splits may set things right. Patching, too, is sometimes used in the case of a tear or hole in an otherwise good canvas. Otherwise, resort is generally had to *lining*.[1] This consists in fastening to the back of the original canvas another piece, large enough to give a sufficient margin for attachment to the stretcher. Occasionally, however, especially with small paintings, a panel may be used instead of a lining canvas. In the past, size was the adhesive almost invariably used. This has the disadvantage of being a source of attraction to moisture and fungi, and if too freely used, both the original and the lining canvas may swell, so cracking or detaching ground and paint. Also, size is liable to lose its holding power in patches, and leads to bubbles forming between the two canvases, as a result of their expansion and contraction. Moreover, to secure good adhesion at the beginning between the two canvases, considerable pressure may be necessary, secured by the use of a heavy iron, which often flattens the impasto of the paint, producing a smooth glassy surface where variations in texture and thickness were the artist's intentions. Consequently, in modern practice, wax is being increasingly used as the adhesive in lining. Complications may be introduced by the necessity of removing an old lining canvas, though this makes no difference in principle. Sometimes, however, the original canvas is in such poor condition that lining cannot make good its defects, and transfer to another canvas is necessary, which is carried out by essentially the same methods as in the case of panels.

A precaution that is sometimes taken with wood and canvas supports is to apply a coat of paint or a layer of wax to the back, examples of the use of paint in this way being known as early as the fourteenth century. The purpose is to reduce the area liable to absorb moisture, and also to give the back of the support a coating which will contract or expand at about the same rate as the coating on the front, and so diminish the risk of warping.

Even if the support remains solid and expands or contracts only

---

[1] In the past and today, often called *relining*. Strictly this term should be used for a canvas that has once been lined, and is lined again.

normally, the ground and paint layer may develop their own defects. Gesso may become dry and brittle, due to the size in it losing holding power. This may lead to its becoming detached from the support, and crumbling in places, so that even a slight movement in the support may lead to cracks, and the ground may cease to hold the paint layer, which may then blister or crack. Alternatively, an excess of size in the gesso may attract damp, leading to swelling and cracking, or be a breeding-ground for mould, leading to decay and discoloration. Grounds in which oil or an oil varnish are constituents are tougher and less liable to speedy decay; but the oil in them may darken, and lower the tone of the painting. If, however, as certain recipes suggest, a spirit varnish made with one of the softer resins is used, this may soon begin to disintegrate, and lead to cracks in both gesso and paint.

The paint layer has its own weaknesses. Most of these have already been described in previous chapters, such as darkening due to the use of oil, both in the medium and for oiling out, the thinning of paint, and cracking caused by the use of a fragile medium or by unskilful or premature juxtaposition of paint layers. Changes due to unstable pigments, or to such pigments being imperfectly protected by the medium, have also been mentioned. Yet another possible source of trouble is failure of the medium to hold the paint firmly to the ground, leading to scaling and cracking.

Finally, the protective coating on a painting may itself deteriorate, or even endanger the paint beneath. In any case, it is very likely to yellow or darken. Some, however, of the darkening and discoloration attributed to a varnish, have been found to be due to a 'tone' or layer of colour put on the surface of the painting before it was varnished to give it what was considered a more agreeable appearance, this tone itself having changed in time. Apart from this, if the varnish is heavy and tough, as in the case of an oil varnish, during the process of hardening it may contract enough to tear the paint, and produce cracks. If, as is desirable, it is thin, soft, and easy to remove (as with spirit varnishes made from the softer resins such as mastic or damar), it is likely to begin to disintegrate within a few years.

This generally takes the form of cracking into a network of tiny cracks, which produce somewhat the effect of ground glass, giving a whitish appearance and sometimes completely obscuring parts of the painting. To the inexperienced eye this is apt to look most alarming; in fact, it is one of the least of the ills to which paintings are subject, since it indicates that the varnish is approaching the state of a powder and can easily be removed.[1] Sometimes, again, a varnish may *bloom*, i.e. a whitish or bluish film appears either on the surface or within the varnish. This has now been proved to be due to minute particles of moisture having become incorporated in the varnish, which as they evaporate leave tiny pits and fissures behind them. This, again, looks like a major disaster, but in fact can easily be corrected by gently polishing the surface or by removing the varnish and revarnishing. A method of treating disintegrated varnish which was much in vogue at one time, and to which the reader may sometimes find references, is known as the Pettenkoffer process, from the name of its chief popularizer. The basis of this is exposure of the disintegrated varnish to alcohol vapour, which melts the varnish, so that it sets again with a new glossy surface. This is little used today, however, on the ground that its action is not easily controlled.

Treatment of deterioration in the ground, paint, or protective covering, is generally from the front of the painting. Sometimes, where the trouble lies in the ground or more rarely in the paint, this may be ineffective or too difficult, and approach has to be from the back, up to the point of transferring. This is mentioned here, to make clear that a painting has not always been lined or transferred because of trouble in the support. Assume, however, the approach is from the front. A preliminary step, usually indispensable, is to take off surface dirt which has often hardened into a tough film which may need skilled hands and even a solvent to remove it. It is often assumed by owners that this is work for the house-maid, and in the past much damage has been done to paintings by amateurs trying to remove

---

[1] This readiness of certain varnishes to splinter makes possible their removal by gentle rubbing with the finger tips; a process calling for patience, tenderness, and endurance on the part of the operator.

dirt by methods recommended in periodicals and books of household hints. Next, removal of the varnish usually has to follow. As mentioned above this can in certain circumstances be done by gentle friction; though almost invariably solvents of various types and strength are used. If these are powerful, and the operator is not sufficiently experienced or skilful, he may remove with the varnish some of the paint; while if the solvent is mild and the varnish tough, overmuch rubbing may have the same effect. In either case, the colour may be changed by removal of a final glaze; subtleties of modelling may be to some extent obliterated; and even solid paint may take on a thin look, to the extent of the tops of inequalities in the ground appearing as a series of tiny light dots owing to paint having been rubbed off. The painting is then described as *rubbed* or *skinned* either wholly or in part. Should this happen, restorers have been known to put a glaze over the damaged area, or even a coat of solid paint, which accounts for many of the *repaints* on pictures.

In the case of scales and blisters the solvents used in removing the varnish may occasionally have softened the paint enough for these to be laid down and to adhere to the ground. Usually, however, an adhesive has to be injected into them with a hypodermic syringe. If the ground is suspected of disintegrating, size or wax may also be introduced to help bind it together in places where blisters or cracks in the paint suggest that the ground is weak. If, as sometimes happens, fragments of paint, or fragments of paint and ground together have fallen, resulting in a hole, this will be filled with gesso or some material similar to that of the ground to bring the surface to the required level. The resulting spots are then tinted out with colour. The modern practice is to limit this tinting out to the damaged area, when the practice is known as *in-painting*; but in the past the difficulty of matching the tint with the surrounding paint often led to the whole area round the damage being *repainted*, a term now generally used whenever the original paint is covered to a greater or less extent. As to how far in-painting should be carried there is difference of opinion. One view is that nothing should be used but a neutral tint, merely to prevent the damage catching the eye; while at the opposite

extreme is the practice of reconstituting as far as possible the forms and colours of the missing area. In many museums and galleries, examples of both types of in-painting may be seen, together with various kinds of compromise between the extremes.

Repainting, however, as previously noted, was often inspired by other motives than to conceal damage. Whatever the reason for their existence the removal of repaints is often necessary. Apart from the desire to get back a painting as nearly as possible to its original appearance, is the fact that even the most skilful and honest in-painting or repainting in the past may have darkened or changed colour, and disfigure the picture. Moreover, heavy and extensive repaintings of the past have often taken the brunt of mishaps to a painting, and have even protected the original paint; so that if they are removed, this may be revealed as in a comparatively good state.

For the removal of repaints, as of varnish, solvents are usually employed, though sometimes scraping or chipping with a sharp blade may be used; and the same risks are run of injuring the original paint surface. It should be emphasized here, however, that when varnish or repaints are removed, and a painting is seen to be rubbed, this is less likely to be due to the conservator of today, than to ignorance and unskilfulness in earlier cleanings, often carried out by amateurs.[1] One of the difficulties which may have to be faced in the removal of repaints is that, often with the best intentions, they were carried out with materials which have so hardened that they will only yield to solvents likely to damage the original paint near or beneath them. Skill, ingenuity, and patience can generally overcome this difficulty; but sometimes a conservator will wisely leave an obvious repaint on a picture, especially if this be a precious one, rather than risk damage by its removal. Another problem is that of being sure a repaint is truly a repaint. The story goes that an ardent young museum director, as a result of surface examination, and the sight of an X-ray, decided that a Rubens was repainted. The apparent

[1] Rembrandt's *Night Watch* at Amsterdam, most skilfully and tactfully cleaned some years ago, was apparently rubbed with sand at some point in its history.

accretions were removed, when it was realized, too late, that the repaintings were indeed such, but by Rubens himself.

It has to be recognized that there are some kinds of change and deterioration in paintings concerning which the restorer can do nothing. Cracks due to the use of asphaltum are an example. Temporarily, these can be made less obvious by softening the paint with a solvent, and smoothing its surface, but since the paint never hardens enough to hold it in place, the cracks will inevitably reappear. Chiefly, however, changes that have to be accepted as irremediable are those in the colour of pigments. There is no known means of bringing back to their original state a copper blue or a verdigris that has gone black, nor of making lighter the darkened shadows on many seventeenth-century paintings. Such changes have to be regarded as part of the history of a picture; and imagination based on knowledge have to be called into play to estimate how the artist intended his work to look.

Another warning is necessary. In recent years the use of scientific means for examining works of art has developed immensely. By the use of X-ray, ultra-violet light, infra-red rays, and chemical and spectroscopic analysis, far more can be discovered about the physical character of the different parts of a painting, and the way those parts are combined, than was possible before. New and powerful means are now, therefore, available not only for finding out how and from what materials a painting was originally constructed, but what may have been added to it later; the possibilities are increased of accurately diagnosing the causes of deterioration in a painting, so that proper and effective remedies can be devised; and the detection of forgeries and impostures has been made easier, by revealing the use of materials or methods of construction incompatible with those available at the time to which the work purports to belong or with those used by the artist in genuine examples.

It cannot be too much emphasized that all that these methods of investigation do is to provide a body of new facts, which have to be observed, recorded, and interpreted by human intelligence. The possibilities and above all the limitations of any particular means of

investigation have to be thoroughly understood if it is to be service-able. For example, the use of X-ray is based on the fact that it will not penetrate certain metals. If, therefore, a painting is exposed to X-ray, and a photographic film is put behind it, what results is a kind of map of the substances in the painting penetrable in a greater or less degree by the ray. But the ray is quite indifferent as to whether those sub-stances were put there by the painter of the picture or by somebody else, and ignores entirely additions, however new, through which it can pass freely. So there is little to justify a widespread and touching belief that in some mysterious way scientific methods of examination will 'tell undoubted Raphaels from Gerard Dous and Zoffanys'; all they do (though that is a great deal) is to provide material for human judgement.

# BOOKS FOR CONSULTATION AND
# FURTHER READING

N.B. This is not a bibliography, but a highly selective list. Full bibliographies will be found in Gettens and Stout, cited below.

## GENERAL

*(a) Early authorities*

CENNINO D'ANDREA CENNINI: *Il Libro dell' Arte* (The Craftsman's Handbook). Translated by Daniel V. Thompson, Jr., Newhaven, 1933. (Dover reprint)

An accurate and lively translation, with full explanatory notes, of an invaluable and most readable account of fourteenth-century Florentine practice.

MERRIFIELD, MARY P.: *Original Treatises dating from the XIIth to XVIIIth centuries on the arts of painting*, etc. London, 1849. (Dover reprint)

With introduction, prefaces, translations, and notes.

*(b) Later works*

BERGER, ERNST: *Beiträge zur Entwicklungs-Geschichte der Maltechnik*, 4 vols. Munich 1901–12.

Learned, authoritative, and covers much ground.

CHURCH, SIR ARTHUR H.: *The Chemistry of Paints and Painting*, 4th edit., London, 1915.

Now somewhat out of date but contains much useful information, systematically arranged.

DOERNER, MAX: *Materials of the Artist and their use in Painting*. Translated by E. Neuhaus, New York, 1934.

Mainly useful to the practising artist, but with some analysis of past methods.

GETTENS, RUTHERFORD J., and STOUT, GEORGE L.: *Painting Materials*, New York, 1942. (Dover reprint)

A short encyclopaedia, arranged alphabetically under different headings. Concise, clear, and authoritative, though occasionally and necessarily too technical for the layman.

LAURIE, A. P.: *The Materials of the Painter's Craft*, London and Edinburgh, 1910.
Covers up to the end of the seventeenth century. The most detailed of several books by the author.

—— *The Pigments and Mediums of the Old Masters*, London, 1914.
Largely repetitive of the author's earlier book.

—— *New Light on Old Masters*, London, 1935.
To some extent repetitive of earlier books by the author but includes material on nineteenth-century painting.

MOREAU-VAUTHIER, CHARLES: *The Technique of Painting*. Translated from the French, London, 1912; New York, 1928.

RUHEMANN, H., and KEMP, E. M.: *The Artist at Work*. Penguin Books, London and Baltimore, 1952.
Introductory—useful for its many illustrations, some in colour.

## CHAPTER 2

ANTAL, FREDERICK: *Florentine Painting and its Social Background*, London, 1948.
Section II 3; Section III 3; Section II 4; Section III 4. For the Florentine guilds and the social standing of the artist.

CIASCA, RAFFAELE: *L'Arte dei Medici e Speziali nella Storia e nel Commercio Fiorentino del Secolo XII al XV*.
A standard book, giving sources.

CONWAY, SIR MARTIN: *The Van Eycks and their Followers*, London, 1921.
Chap. VIII on the Guilds, giving numerous further references to earlier authorities.

ELST, BARON JOSEPH VAN DER: *The Last Flowering of the Middle Ages*, New York, 1944.
Part I, Sec. V on the Flemish Guilds. A short popular account, unfortunately giving no references or sources.

HAUSER, ARNOLD: *The Social History of Art*, London, 1951.
For guilds: IV, 10; V, 2, 3; VI, 1.
For guilds and the effect of social changes on painters.

MARTIN, W.: 'The Life of a Dutch Artist in the Seventeenth Century'. *Burlington Magazine*, May 1905, p. 125; September 1905, p. 416; October 1905, p. 13.

PEVSNER, NIKOLAUS: *Academies of Art, Past and Present*, Cambridge and New York, 1940.
Important for the Renaissance and later.

## CHAPTER 3

DE WILD, A. M.: *Scientific Examination of Pictures*, London, 1929.

Especially useful on the subject of pigments.

## CHAPTERS 4–6

MERRIFIELD, MARY P.: *The Art of Fresco Painting*, London, 1846.

A collection of materials, rather than a systematic treatise. Most useful for its references to and transcriptions of early authorities.

SCHMID, HANS: *Enkaustik und Fresko auf Antiker Grundlage*, Munich, 1926.

THOMPSON, DANIEL V.: *The Materials of Medieval Painting*, London, 1936.

(Dover reprint, under the title *The Materials and Techniques of Medieval Painting*)

Clear and authoritative. Also contains much information on processes.

THOMPSON, DANIEL V.: *The Practice of Tempera Painting*, Newhaven, 1936.

(Dover reprint)

Primarily for the practitioner, but with historical references.

## CHAPTER 7

EASTLAKE, SIR CHARLES: *Materials for a History of Oil Painting*, London, Vol. I, 1847; Vol. II, 1869.

(Dover reprint, in 2 vols., under the title *Methods and Materials of Painting of the Great Schools and Masters*)

Voll. II was prepared for the press by Lady Eastlake from material left by the author. Despite its early date, it remains one of the most authoritative and suggestive books on the subject.

## CHAPTER 8

MEDER, JOSEPH: *Die Handzeichnung*, Vienna, 1919.

Parts II and III especially. A classic.

SCHMID, F.: *The Practice of Painting*, London, n.d. (c. 1945).

Useful for seventeenth- and eighteenth-century practice, especially for colours used and palette arrangements.

## CHAPTER 9

STOUT, GEORGE L.: *The Care of Pictures*, New York, 1948. (Dover reprint)

Clear and authoritative.

Further references to authorities on particular points are made in the text.

# INDEX